THE ILLUMINATED ALPHABET

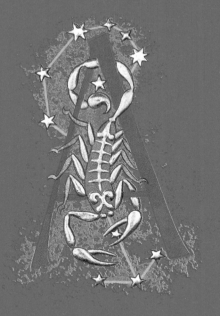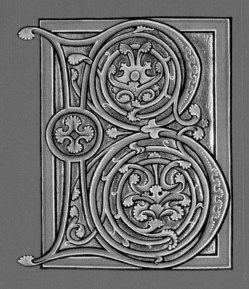
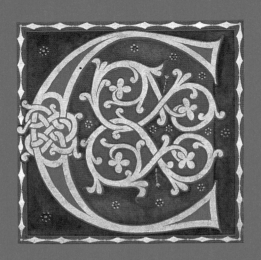

THE ILLUMINATED ALPHABET

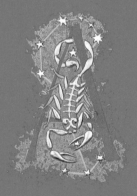

Calligraphy by **TIMOTHY NOAD**
Text by **PATRICIA SELIGMAN**

RUNNING PRESS

PHILADELPHIA · LONDON

ISBN 1-56138-458-5

Library of Congress Cataloging-in-Publication Number 93-87600

This book was designed and produced by
Quarto Inc.
The Old Brewery
6 Blundell Street
London N7 9BH

Cover artwork Timothy Noad
Designers Peter Bridgewater/Annie Moss
Managing editor Anna Clarkson
Picture researcher Felicity Cox
Photographer Nelson Hargreaves
Art director Moira Clinch
Editorial director Sophie Collins
Typesetter Chris Lanaway

Manufactured in Singapore by
Bright Arts (Singapore) Pte Ltd

Printed by Star Standard Industries (Pte) Ltd
Singapore

This book may be ordered from the publisher.
Please add $2.50 for postage and handling. But try your bookstore first!

Running Press Book Publishers
125 South Twenty-second Street Philadelphia, Pennsylvania 19103-4399

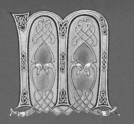

CONTENTS

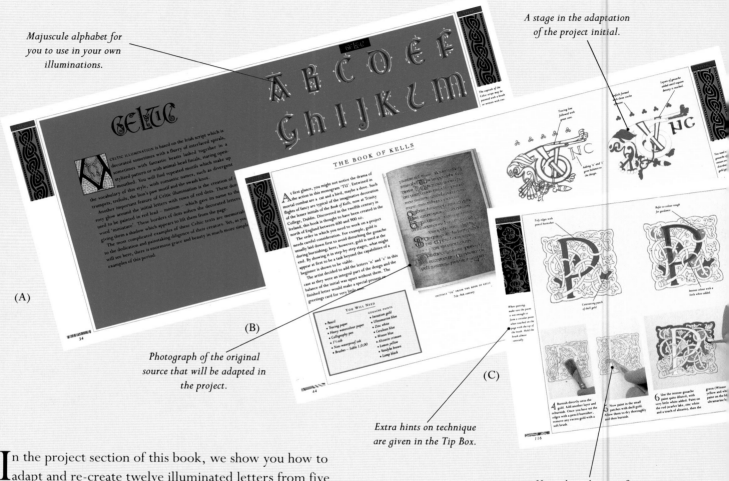

Majuscule alphabet for you to use in your own illuminations.

A stage in the adaptation of the project initial.

(A)

(B)

(C)

Photograph of the original source that will be adapted in the project.

Extra hints on technique are given in the Tip Box.

Here, the technique of burnishing is clearly shown.

In the project section of this book, we show you how to adapt and re-create twelve illuminated letters from five different historical periods: Celtic, Romanesque, Gothic, Renaissance and Modern Revival. The spreads featured above show how the information on the styles and projects is presented.

Each style begins with a spread (A) which contains information about the development of the style. The spread also features a complete majuscule (upper case) alphabet for you to use in your own illuminations.

Each of the projects also has an introductory section (B) with a photograph of the original source and information on how the source was adapted and re-created for this book by the artist, Timothy Noad. The creation of the illumination is then shown (C) in step-by-step photographs, and accompanied by full instructions and tips on techniques.

The project ends with two spreads (D), which show the artist's experimental sketches before beginning his adaptation of the illumination; letters and complementary borders are illustrated. Use these sketches to inspire your own ideas. A minuscule version of the alphabet from the historical style is included for you to use in making up full words in your illuminations.

Each of the five styles finishes with a gallery (E), showing other illuminations from the period.

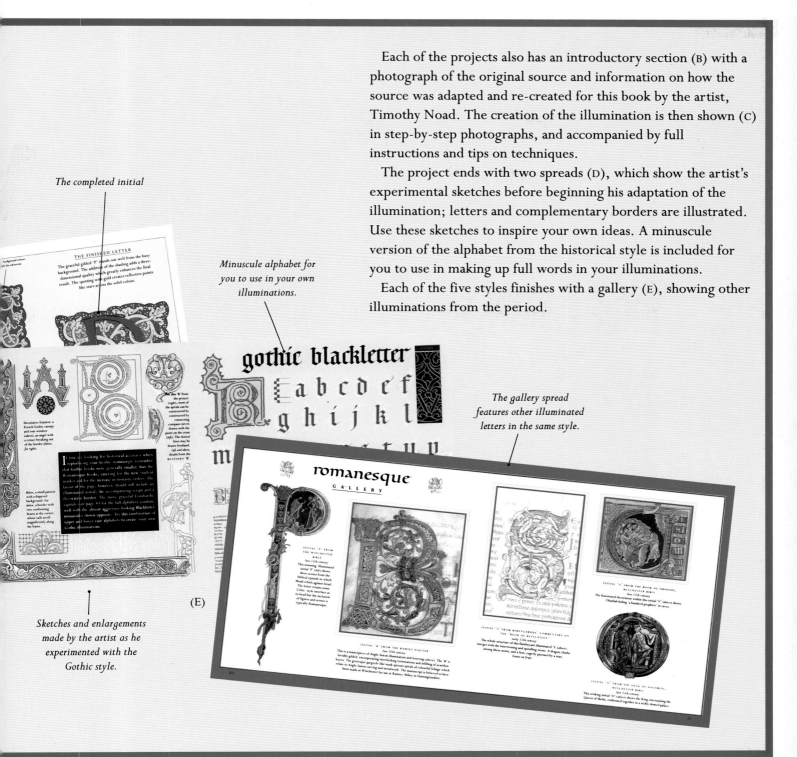

The completed initial

Minuscule alphabet for you to use in your own illuminations.

The gallery spread features other illuminated letters in the same style.

Sketches and enlargements made by the artist as he experimented with the Gothic style.

(E)

The HISTORY of ILLUMINATION

If you have ever looked closely at any medieval illuminated manuscripts, you will probably be struck by the fact that its survival is a miracle. Illuminations are obviously delicate works of art, with intricate designs painted and embellished with gold on parchment and vellum, and yet they were often handled daily by generations of owners – monks or priests, academics or courtiers – as they turned the pages to learn or teach from them, or merely to look at them. Often such illuminated manuscripts were taken on travels overseas – and yet you can still see them today, with the brilliance of the gold leaf and the rich colors of the painted pigments as fresh as ever.

In the first part of this book, we glance back over the history of illuminated letters, at the artists who created them as well as the patrons who commissioned them. In the second part of the book, twelve illuminated letters are adapted from original masterpieces, and their re-creation is clearly demonstrated in step-by-step stages, starting with an initial from the Lindisfarne Gospels and finishing with a contemporary horoscope letter created in the 1990s.

Examples of illumination from the LINDISFARNE GOSPELS *(above), and* LES GRANDES HEURES *of the Duc de Berry (right).*

WHO WERE THE ARTISTS?

There are medieval drawings and paintings which show monks at work in cloisters, bowed over books, pens in hand. They were busy transcribing or illuminating books for people to learn from and pray with, and books to be used for missionary work. The magical properties which illumination gave to medieval books heightened the standing of their creators: we even know the name of the scribe and illuminator of the Lindisfarne Gospels, Eadfrith, who became Bishop of Lindisfarne in May of 698.

When book illumination became more widely desired by the richer merchant classes at the beginning of the thirteenth century, illumination moved out of the cloister. This created the need for secular scribes and

luminators who would travel to the new university towns and centers of learning to work. The famous Limbourg brothers, who gave life to *Les Très Riches Heures* for the Duc de Berry, moved from the Low Countries to take up work in Paris.

HOW DID THEY WORK?

We can learn much about medieval book production by looking closely at the pages of original manuscripts. Equally, miniatures showing monks at work, particularly the Evangelists from books of gospels, reveal a great deal.

First of all, the materials – vellum and parchment, ink, colored pigments, powdered gold, and gold leaf – would be prepared and gathered together. The vellum and parchment, from calf or sheepskin, was laboriously prepared: soaked in water and lime, then scraped and stretched. Once dried, the vellum was folded into halves, quarters or eighths, depending on the required size of the book. These pages would then be trimmed and stitched together. Ink was made from powdered carbon – soot or lamp-black or irongall – which was kept in a cow horn, and materials for the colored pigments came from a variety of animal, vegetable, and mineral sources.

Often, the scribe would be making an exact copy of another text, so he needed to mark guidelines and rules onto the pages. He did this by marking the top sheet, then piercing through a sheaf of leaves with a sharp tool to form holes on all the pages. These would then be joined together when each new page was started.

Once the materials had been gathered and prepared, the paper marked, and the illuminator had indicated the spaces needed for the decorated borders, initial letters

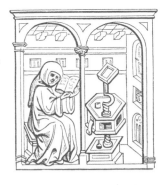

This fourteenth-century woodcut, now preserved in the library of Soissons in France, shows a monk at work in a cloister.

and miniatures, the scribe could begin work. A portrait of the monk Eadwine, the "prince of all scribes," from a Psalter and Gloss made in Canterbury, c. 1150, clearly shows the method of working – with a pen in one hand and a curved knife in the other, the latter being used for sharpening the pen and scraping out mistakes. From this, we can also tell that the techniques of illumination used today are very similar to those used in medieval times. See the section on Materials and Techniques for further information.

WHY WERE BOOKS ILLUMINATED?

Religious texts – gospels and psalters – were originally illuminated to honor God, but some of this decoration seems a little lavish simply for devotional purposes. Indeed, it had other uses. From a purely practical point of view, illumination, for example of the gospels, helped a missionary or priest to find his way around the text. There were full pages of decoration between each gospel, and decorated initials gave a visual clue to the contents of the page. For the missionary, certain miniatures were painted with a large audience in mind. In the Lindisfarne Gospels, for example, the full-color, stylized portraits of the Evangelists could have been seen at some distance.

Books in medieval times bestowed a certain standing upon their owners, and illuminated books, in particular, represented wealth and power. Missionaries could take full advantage of this, as well as Carolingian emperors, kings, and feudal princes. For example, in early medieval times, medicines made from water in which

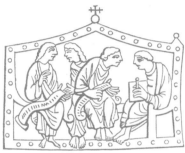

This Anglo-Saxon woodcut shows a group of monks with rolls of parchment ready for illumination.

pages from a holy book had been soaked were taken in the belief that they were cures for certain illnesses. Equally it was believed that the books, if tampered with, could inflict great pain.

Throughout their history, illuminated books must also have been appreciated as works of art, and certainly in the Renaissance they were commissioned and collected as such. Let us take a brief look at the style of these works as they developed over the centuries.

DEVELOPMENT OF STYLES

Above, right, a detail from a page of the BOOK OF KELLS.

The breakup of the Roman empire almost destroyed the art of illumination, and the use of friable papyrus meant that there are very few surviving examples from this early classical period. But the art slowly re-emerged in France, Spain, Ireland, and Northern Britain; described as the Insular style and painted on more durable parchment or vellum, it was heavily influenced by invading tribes from the North.

A detail taken from the LINDISFARNE GOSPELS, *c. 698, (right) showing a number of illuminated letters encased by little red dots, known as rubrication.*

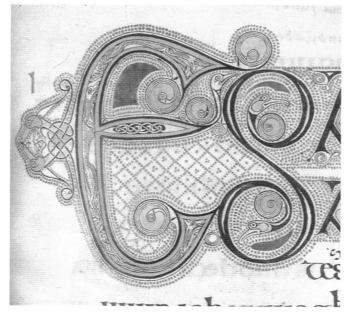

Celtic-extremes in style

The Celtic style came within the general term of Insular style. Developed in Celtic Ireland, it was taken to Scotland by a group of Irish missionaries led by St. Columba in 563. They established a monastery on the island of Iona in western Scotland, and in 635 they founded the monastery of Lindisfarne on the Northumbrian coast. where the Lindisfarne Gospels were transcribed and decorated, c.698.

A page from these Gospels can be recognized by the clarity of the linear design – in the spirals, interlaced and intertwined birds and animals – and the purity of the color – bright blue, green and red, shades of pinks and purples, as well as yellow used instead of gold. The pages were also given a unique rosy glow by the outlining of the letters with tiny red dots, known as rubrication. "Carpet" pages of abstract design – knotwork and interlacing – break up the Gospels' and full-page portraits of the Evangelists are stylized.

The Book of Kells, which shows another face of Celtic art, was first discovered in the twelfth century in Kells, outside Dublin. It, too, may have come from the north of Britain. The principal initial letters are richly decorated in a glorious combination of motifs: circles within circles, intricate knotwork, and human heads. The work is highly imaginative and sophisticated and, compared with the Lindisfarne Gospels, there is an unconstrained sense of freedom in the design.

Anglo-Saxon

601, the first missionaries came to the south of
ngland from Pope Gregory the Great in Rome. Even
ith such Roman influence, early examples of Anglo-
axon illumination, in the eighth and ninth centuries,
how much more Celtic influence in the script and
ecoration. Closer to these roots, and a great influence
ven beyond the shores of England, was the Winchester
chool, which flowered in the tenth century. The style
f this school was characterized by the elongated necks
nd rippling drapery of its figures, which defy the
aturalism of antiquity and capitalize on an early form
f expressionism.

Later Anglo-Saxon illumination was influenced by
lassical Roman and Byzantine sources – the figures
ere more solid, and the drapery hung in plate-like
olds. In general, the illumination was richer and more
ophisticated, and the classical curling acanthus-leaf
ecoration became popular.

A late example of Anglo-Saxon illumination, from
he Grimbald Gospels (pages 56-9) which were
ompleted in the early eleventh century, shows Celtic
nfluence in the design of the knotwork, but the
gures and the border reveal a classical influence.

a b c d e f

Above, *letters from
the Carolingian
Minuscule alphabet.*

Left, *a detail of an
initial "I" from the*
WINCHESTER
BIBLE, *c. 1160. Note
the details in each
picture and the
brilliance of the
burnished gold.*

Revival of
Classical Idioms

While missionaries continued to
struggle across Europe carrying
their illuminated manuscripts, other
centers of book production
emerged. One such center was the
court of Charlemagne, who was
crowned Emperor of the West in
800, in Rome. Charlemagne's love
of books and his realization of the
power of the written word helped
to establish illuminated works as
essential possessions for the rich
and powerful. Popular manuscripts
included classical texts, such as the
works of Horace and Cicero, as well
as standard religious works, such as
gospels and psalters.

Design and content at this time
were influenced by classical sources,
often with gold script on purple-
stained vellum, in the manner of the
Roman Emperors. A new script,
called Carolingian Minuscule, was
introduced by Charlemagne. It was
small and round with vertical
ascenders and descenders and so was
easy to read and write. Humanists of
the later Renaissance period
believed these texts to be classical
originals, thus the first script used
for printing in the fifteenth century
was based on Carolingian
Minuscule. This script has since
been passed down to us as "Roman."

The Gospels of Otto III

Illumination went into decline after Charlemagne's death in 814, until Otto III, crowned Holy Roman Emperor in 983, revived the splendor of Charlemagne's court and with it the importance of illumination. The golden binding from the Gospels of Otto III has survived, complete with studded jewels and pearls, classical carved stones, and insets of Byzantine ivory. As you can see from the Ottonian "V" (pages 64-7), the illumination of the period was every bit as rich – lavishly decorated with gold and painted the colors of precious gems.

Above, the adaptation of an Ottonian initial "V" shown in the project on pages 64-7.

Romanesque

In Britain, a further development of the Insular style in combination with the classical Roman style resulted in the style called Romanesque. At this time, the historiated initial a letter depicting a narrative scene in its center, became more popular, as well as decorations of writhing, snapping beasts.

These stylistic developments can be seen in an enchanting illuminated initial letter "D" (*above, left*), which appears in a twelfth-century Gloss on the Psalms, now in Lincoln Cathedral Library in England. It shows increased interest and naturalism in the representation of the human figure. In the project on page 72, you will see King David swaying to the music and the strings of the harp dancing beneath his fingers.

Early Gothic

Alongside the religious orders, kings, princes, and courtiers, a new market for illuminated books developed in the thirteenth century among the rising middle classes. Psalter and bestiaries were popular but very expensive, so many households owned just one or two.

Signs of Gothic influence in medieval illumination are easier to identify in the miniatures of the period, where figures are finer and adopt the Gothic sinuous sway. Changes in letter decoration are n so obvious, although the new popularity of books resulted in smaller volumes and illumination on a reduced scale. The initial in the project on pages 84-7, taken from a bestiary in the British Library, c.1200, shows a refinement of line and the start of more natural, decorative leaf forms which distinguish it from its Romanesque predecessors.

High Gothic

The book of hours became very popular in the fifteent century. It was a devotional book used by laymen for

An intial "D" from a fifteenth-century book of hours (right). It can be seen in position on the original manuscript on page 72.

Below, right, a detail from LES GRANDES HEURES painted by the Limbourg brothers, c. 1400.

ayer, and contained a yearly calendar with the
ccupations of the Months and the Hours of the Office
the Virgin, each illustrated with a miniature.

Perhaps the best known of the High Gothic patrons
as Jean, Duc de Berry (1340-1416), who
mmissioned a book of hours for the glory of owning
work painted by the three Limbourg brothers.
owever, both patron and all three artists died before
completion. Miniatures from this book are still to be
arveled at for their depiction of everyday life and their
e of clear jewel-like colors.

Decoration became increasingly natural, too.
uminated letters from *Les Très Riches Heures*, as well
the *Duc de Berry's Psalter* (pages 92-7), appear to be
tertwined with growing flowers and leaves. Such
tters were highly gilded, emphasizing the courtly
fluence of the High Gothic style.

Realism

was the Italian humanists of the Renaissance who
ined the term "Gothic" to define what they saw as
e barbaric art that had come before the rebirth of
assical learning. What they aspired to was the
tellectual knowledge and realism of the classical
tists of Greek and Rome. This required artists to
search all sorts of subjects that would not have been
cessary in the past and which, in time, gave the artist
new role in society. The illuminated letter
emonstrated on pages 102-5, from the story of David
d Bathsheba, was painted in fifteenth-century France.
he pansies which feature in the center of the letter are
inted on gold and crudely depicted, but are no less
sy to recognize. No longer are the foliage and petals
neralized – even in such tiny details, truth to nature
as expected.

This new realism percolated quickly down to the art
the illuminator, particularly in schools in Italy, such

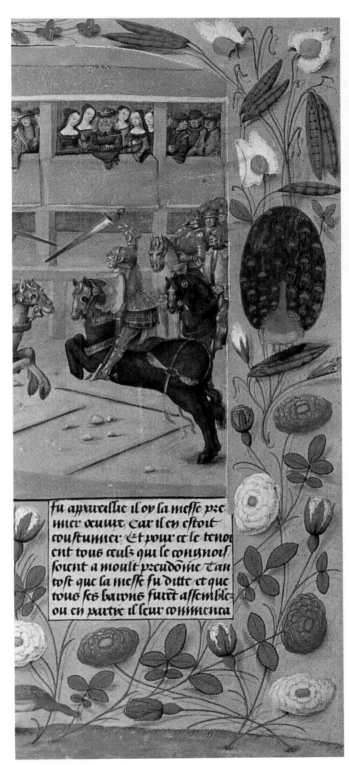

This detail from a highly decorative page of illumination (left) shows all the elements of Gothic realism: a picture of a tournament watched by King Arthur and his courtiers and an illusionistic border of flowers and birds.

as Venice and Florence, that were attached to the city republics. Indeed, illuminators were busy all over Europe keeping abreast of the tide of commissions, which came not only from princes and courtiers, but from men made rich by wool, banking or trade. An important school thrived in the Low Countries at this time in Ghent/Bruges. From this came the *Hastings Hours*, c. 1480, which was made for William, Lord Hastings, in which a height of realism is reached in trompe l'oeil margins, strewn with flowers which cast shadows on a gilded ground.

Whitevine interlace

Borders and letters intertwined with a flourishing climbing vine, known as Whitevine interlace, became fashionable in the early fifteenth century. The Italian humanists copied this type of motif from twelfth-century Italian manuscripts, believing they were reviving a classical motif. It thrived and was distributed from the humanist center in Florence.

A detail from an initial "A" (right), showing rampaging Whitevine interlace with white and gold dots, grouped in threes.

Below, right, this initial "F" from the Renaissance period has been carefully painted to give a three-dimensional effect.

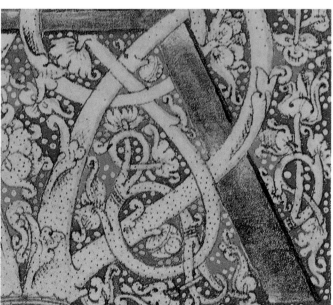

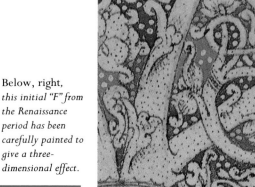

This parrot is typical of the flights of fancy often hidden among the Whitevine interlacing.

Whitevine interlace was mainly used to decorate the borders and initials of classical texts such as Thucydides *De Bello Peloponesium*, commissioned by Cardinal Jean Jouffrey in 1470, who wished to present it to King Louis of France. It also decorat the initial from the project on pages 114- Humanists attached great importance to the perfection of the script, and this style of decoration adds a note of restrained grandeur. Many Whitevine illuminations typically featured a variety of beasts and flying birds which wou break through the formal pattern of interlacing aroun the initial or perch jauntily on the edge of the intertwining border.

Classical

The Italian Renaissance generated an even wider interest in collecting books. Some bibliophiles concentrated on obtaining classical Latin texts and, when the originals were not available, they commissioned copies. Vespasiano da Bisticci (1422-9 the great Florentine bookseller, organized thirty-five scribes to complete 200 manuscripts in almost two years for the library of Cosimo de Medici.

Vying for popularity with the Florentine Whitevine style, a more classical style based on early Roman inscriptions emerged in the midfifteenth century in northeastern Italy. The initial from Homer's *Iliad* (pages 122-5), now in the

...tican Library in Rome is in this classical style. The ...ge is framed in an architectural border – a ...reedimensional illusion supporting the two ...nensions of the written page. The initial letter is also ...ee dimensional, gilded and painted to look like ...man inscriptions in stone, then decorated with ...ssical motifs – acanthus leaves and medallions.

Arts and Crafts

...e invention of printing in 1471 had no immediate ...ect on the art of illumination. Books continued to be ...nscribed and decorated; indeed, some of the first printed books were illuminated with borders and initials. Slowly, though, the art died out, taking with it the skills of the artists and craftsmen.

It was not until the birth of the Arts and Crafts Movement in England after the Great Exhibition of 1851 that the techniques of illumination were rediscovered. This movement, spearheaded by William Morris, disliked the poor workmanship that resulted from mass production and tried to re-establish the mastery and appreciation of manual arts and crafts. Morris himself practiced several of the skills that were re-learned and went on to study medieval illumination. The Kelmscott Press, founded by Morris in

1890, regenerated public interest in fine book production. He illuminated the monogram adapted on pages 134-7 in the dedication of a poem.

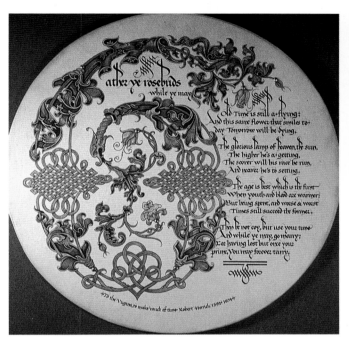

Contemporary Illumination

Despite the painstaking and time-consuming character of illumination, this art not only survives today, but thrives in schools and colleges, and is practiced by individual artists. Rather than schools of artists, there exist individuals who have made a name for themselves. Work is mainly executed to commission and is nurtured by the late twentieth-century love of calligraphy and genealogy. But a glance at the work shown in this book will show you just how inventive the modern illuminator can be.

On pages 142-7, you will find a horoscope letter designed for this book by the illuminator Timothy Noad and treated in a decorative contemporary style.

Left, *this illuminated poem,* "Gather Ye Rosebuds," *is by contemporary illuminator Margaret Wood and has been painted in Elizabethan style on vellum.*

Far left, *a typical example of a William Morris border with intertwining plant forms from* THE KELMSCOTT CHAUCER.

TECHNIQUES and MATERIALS

CHOOSING YOUR SUPPORT

Choosing the right paper, board, or vellum is most important for the illuminator. How much you spend will, of course, depend on your purse and your objective. Are you trying out a new technique? Will you use a wet or dry technique? Is the illumination going to be framed? Will it be handled a lot?

Initially, you might want to practice on cheaper alternatives, but you will find it easier with more expensive papers. The cost of such papers may make you nervous, but they can bring out the best in you.

Paper

For illumination, you will need smooth (hot pressed), heavy paper – about 300gm. Watercolor paper is suitable, and if it is heavier than 300gm, it will not need stretching. It needs to be smooth for fine detail and heavy for raised gilding techniques, as larger areas of gesso distort the paper where it soaks up the water. Recommended papers are Fabriano Artistico,

Above, a line-up of paper and vellum. Note the translucent nature of the vellum at the top, compared with the paper below.

Above, you can see how vellum vary, not only in texture but also in color, too.

Saunder's Waterford, or Arches Aquarelle. As these are all quite expensive, try out new techniques on cheaper good quality, smooth stretch paper, which you can buy in a pad or by the single sheet.

Line and wash paper and board

Line and wash paper is pressed to make it very smooth. The paper is reinforced with a backing of cardboard, which can be useful if you are going to frame your work. This paper is also useful if you want to tint your work with an overall wash, as it does not need stretching and will not wrinkle.

Vellum

ost medieval manuscripts were produced on vellum — e prepared skin of a calf, sheep or goat — because it is th durable and supple, and so could endure centuries handling. It is still used today, because of its unique face and properties of durability, but it is extremely pensive. You can buy it in small pieces or, more onomically, in whole skins, but you will have to do ther work on the skin yourself to get good results.

TYPES OF VELLUM

s worth looking at the various types of vellum ailable, with their different textures and colors — des of white, cream, and yellow. All of these treated ns, whether fine or coarse, have their uses and are rth the trouble required to make them workable. Manuscript vellum is highly prepared and particularly e; it is thin, smooth, bleached white, and is finished both sides. Classic vellum is creamy colored, not as hly finished as manuscript vellum, and only treated writing on one side. Natural vellum is also not so hly prepared and so is darker and coarser. It usually eds quite a lot of work before it can be used. oatskin vellum is even coarser and again needs a lot work, but the results are no less beautiful.

BUYING AND STORING VELLUM

ppliers selling calligraphic materials will usually sell eces of vellum by the square foot, which is the best y of buying it if you are trying it out. The cheapest y of buying vellum, however, is by the skin and ually by mail. You will find that the size of the skin ll depend on the animal from which it comes; for ample, the skin of manuscript vellum which comes m a calf is usually about 6-8 feet square. If you have e opportunity to choose your skin, take your time, ecking it carefully for blemishes.

Storing a skin successfully is not easy. It needs to be stored flat in a cool, dryish place: heat will make it crumple, and dampness will cause it to stretch, but if it gets too dry, it will harden and become unusable.

CUTTING VELLUM

Vellum has a smooth side (originally the outer hairy side) and a rough side (originally the inner side of the skin). With some types of vellum, such as manuscript vellum, both sides can be worked on, but the outer side is usually regarded as the better of the two.

 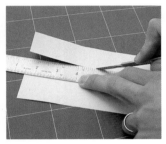

The inner side of a piece of vellum is usually rougher and not so easy to work on.

To cut vellum, use a sharp scalpel or knife and a metal ruler on a thick cutting mat.

The problem with cutting a skin is that it is not a consistent thickness, as you will see if you hold it up to the light. Choose the best part of the skin for the work you are doing, and try to keep any variations symmetrical, i.e., keep the thickest part, usually found down the backbone, in the center of your support.

Always cut vellum on a flat surface. Either a piece of wood, the size of a drawing board, or a rubber cutting mat, which can be placed on a table and cut into, is extremely useful. Use a metal edge or ruler to cut against and a craft knife with a clean, sharp, strong blade to cut with. Map out the shape you want first with a pencil, allowing for margins, for stretching and/or for framing.

PREPARING VELLUM

Vellum has a greasy surface which makes it difficult to work on, so you will need to remove the grease. You will also need to give it a nap which will accept the paint or ink and bond it with the skin, as well as providing a surface which is good to work on. You do all this by treating the surface with an abrasive powder called pounce. Pouncing is rather like sanding.

The pounce is made by grinding up the following ingredients (available from speciality suppliers) to a fine powder in a pestle and mortar:

- *4 measures of cuttlefish bone*
- *8 measures of powdered pumice*
- *2 measures of gum sandarac*

Sprinkle a little pounce onto the surface of the skin and then gently rub it around in a circular motion with a scrap of vellum until the skin feels smooth. The amount of pouncing a skin will need will depend on the quality of the skin. Once you have achieved the desired surface, brush off the powder with a soft brush or clean feather. Make sure you have removed all the surface powder or it may scratch the surface of the gold when burnishing. Do not touch the skin once it has been pounced or you may transfer grease from your hands.

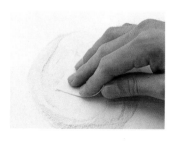

Prepare your vellum by treating it with an abrasive powder called pounce. Rub the pounce over the surface in a circular motion using a scrap of vellum.

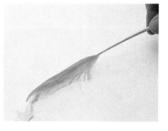

Once the skin feels smooth, gently brush the vellum surface with a clean feather. Save any excess pounce as it can always be reused.

BRUSHES, PENS AND PENCILS

In this book, the artist has used brushes to carry out most of the work: small, springy brushes apply the washes; fine pointed ones fashion the intricate outline and shorter ones dot around the Celtic initial. For the illuminator, brushes have a host of other uses, too; the are used in the gilding process and for applying binder. You do not need to buy a vast array of brushes to get started; it is better to buy one or two and then add to your selection as and when you find you cannot do without a certain brush.

Pens and pencils are also covered here, but in the projects they are used only in a limited way.

Brushes

You can start illuminating with only one brush. It need to be fine, size 0 or 1, and springy, with short rather than long hairs. Sable hair brushes are considered the best, and if looked after well they last a long time. But they are expensive, and the new breed of synthetic brushes control well and produce a fine line. Brushes that are manufactured especially for miniature painting with short, soft, springy hairs for close control, and so called spotting brushes, used for photographic retouching, are also worth considering.

CHOOSING A BRUSH

Take your time to find the perfect brush for your illuminations. A good sable brush is so expensive that most stores will not mind if you ask for some water to try it out on some scrap paper or on the back of your hand. Check that it has a good point that springs back into shape and does not divide when a little pressure is applied. If you find that it is not satisfactory when you try it out at home, you may be able to take it back.

OTHER BRUSHES NEEDED

If you have any older brushes, they can be used specifically for painting on masking fluid or binders, or for "spooning on" gesso. These products are not good for brushes, and sometimes you need to use hot water to clean them, which is not recommended for a sable brush. Nevertheless, you will often have to paint intricate patterns with these brushes, so they will have to be of reasonable quality.

In the gilding process, a larger, square-ended (flat), soft brush (No. 5) is sometimes useful for manipulating the gold leaf or for picking it up when it is about to break up and your fingers are too clumsy. When gilding, too, you will need a big, soft-haired brush for brushing off any spare gold leaf from the surface of your paper or vellum.

Pens

A calligraphy round-hand pen with 1½ nib has been used for many of the small letters in this book.

Two types of outlining pen are tried out in the project section. A mapping pen, which needs to be dipped in the ink — an art in itself — is very cheap to buy, and the long, pointed, flexible point makes it quite easy to control along an intricate outline. A technical pen (Rotring or Staedtler rapidograph) has a reservoir which takes waterproof ink and so does not need dipping. Although purists criticize the result as too consistent — the line does not alter with pressure or by changing direction — it can be difficult to distinguish between the results.

Pencils

Graphite and colored pencils are useful for trying out ideas before you start illuminating a letter. An HB pencil is a good standard pencil for tracing and enlarging (page 31), but you will find a harder, lighter 2H will be better on vellum, where you want the drawing as light as possible.

Pens, brushes, and pencils all have their uses in illumination. As you can see their marks vary, from the left: calligraphy pen with No. 2 size point for use with black ink; mapping pen, which produces a characteristic line; technical pen, which produces a much more consistent line; size 1 sable brush; size 00 sable brush; different leads for propelling pencils; light 2H pencil for work on vellum.

PAINTS AND INKS

Medieval manuscripts were painted using a medium called "egg tempera," which, when seen on cream vellum, appears rich and jewel-like. Today, the illuminator can select from a variety of media which all produce different effects and are worth exploring, including gouache, watercolors, acrylics, colored inks, and fabric dyes.

In this book, we will be copying or adapting mainly medieval examples of illumination, so paints which best reproduce the effects of egg tempera are used. In one project (pages 92-7), egg tempera is tried, but the other projects use only gouache and watercolor. Gouache, which is ready-made, produces a flat, opaque, almost velvety effect which comes very close to the effect of egg tempera. The translucent properties of watercolors are preferred for the naturalistic flowers which became fashionable in the later Renaissance (pages 122-5), for the delicacy of the illusionistic Roman-style letter (pages 102-5), and for the Arts and Crafts project (pages 134-7).

Gouache

Gouache, a water-based paint, is usually sold in tubes. To start with, you will need only a few colors; the palette in this book includes Winsor blue, ultramarine blue, scarlet lake, alizarin crimson, light purple or purple lake, lemon yellow, yellow ocher, Vandyke brown, and lamp black. Cerulean and cobalt blues, and spectrum yellow are also useful for creating more subtle hues. The colors listed above are stable and permanent, meaning that they should not fade or change. Zinc white, which is more translucent, is used for mixing, and permanent white for highlighting.

Begin by squeezing a small amount of paint onto your palette. Dilute the paint slowly, as it is easier to dilute

than thicken. If you are mixing colors, add darker colors to lighter ones, again, a little at a time, making sure you always mix enough paint for the area. Remember, however, that to reproduce the pure colors associated with medieval illumination it is desirable to mix the colors as little as possible.

ADVANTAGES OF GOUACHE

Gouache is opaque, so any mistakes can be covered up with another layer of color. If the first layer is too light when dry, you can just add another, less diluted, layer. Added layers need to be increasingly less dilute, or the previous one will dissolve and come away.

WASH TECHNIQUE

An area of color is easier to fill in if it has already been washed with a thin layer of diluted paint. You can then feed in, wet-in-wet, more concentrated color, which should be the consistency of thin cream.

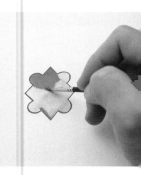

Begin by washing the area with a diluted mix of color. Then outline the area and add stronger color to the center (*right*) using the wet-in-wet technique.

There is an array of colored media from which to choose (below, from left to right): ground pigments, gouache paint, inks, and watercolor.

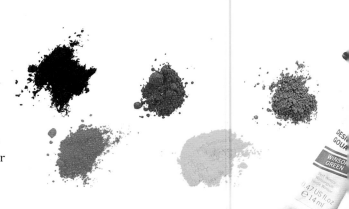

Gouache dries very quickly, so to achieve an even ea of color, first paint around the edge of a mplicated shape and then fill in the center. Use the ll flexibility of the brush to sweep the paint around e area so that the paint is worked as little as possible.

HIGHLIGHTING

or highlighting, use opaque permanent white. You can ash this over an area so that the color below can be en through a veil of white. For points of pure white, lute with a drop of water and apply cleanly.

OUTLINING

ou will see in the project section of this book how tlining helps to redefine the structure of an uminated initial; it is a chance to clean up ragged lges in both painted and gilded areas.

Outlining is a skill which improves with practice, and is one of the secrets of successful illumination. It quires patience, concentration, and a steady hand. ix your paint to a creamy consistency, then take up a tle paint with a fine-pointed 00 brush and paint ound the areas of color.

Instead of trying to use a single line for the outlining, is easier to paint a short stroke and then go back on it, aking the next forward stroke a little longer than the rst. If your line is too light or too narrow, go over it

You can see here how the outline helps to define the shape. It can also help to clean up edges.

A row of consistent dots like this one takes practice. But even the experienced make mistakes. Here, an overlarge dot is cleaned up, using permanent white.

again. But don't worry if the line is not quite consistent – variations in the width give a certain life to such decoration.

If your brush wanders involuntarily into a painted area, you can always overpaint the area and then redo the outlining. Clean up stray strokes on the white paper with permanent white. Mistakes on vellum or gold leaf are more difficult to rectify. You can try scraping paint off vellum very carefully with a scalpel and then burnishing the gold surface. You might be able to remove paint from gold leaf with a clean brush and water, but this may cause the gold to come away. Success depends on the size of the mistake and the material. Vellum is much tougher than paper, and you will have better success with a scalpel. If the paint will not stick to gilded areas, add a tiny drop of detergent liquid or egg yolk to improve strength of adhesion.

Egg Tempera

With egg tempera, the yolk of an egg is used as a binder for pure ground pigment. Water is used to dilute it. Using a good-quality ground pigment, which you can buy in small quantities, produces an intensity of color rarely achieved by ready-made paints. Start with

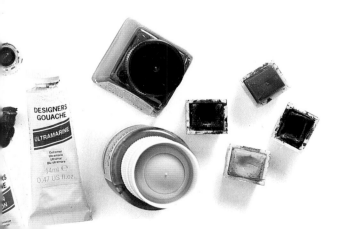

DESIGNERS GOUACHE

ULTRAMARINE

Outremer Ultramarin Ultramar Blu ultramare

14ml ℮ 0.47 US fl.oz.

ultramarine blue, cadmium red, scarlet lake, chrome or lemon yellow, zinc white, and ivory black.

MAKING COLORS

After cracking an egg and pouring off the white, remove the yolk between thumb and index finger by holding gently onto the sac in which it is enclosed. Dry it off on some tissue – the sac is quite robust, but don't get over-confident. Now, holding the sac again, pierce the yolk with a sharp knife so that it falls into a clean bowl or the dried-out shell. Throw the sac away.

Make up your colors by spooning a little ground pigment onto a palette and adding a little water to dilute it. Now add a few drops of yolk with a clean brush – in this way, the yolk does not get dirtied. Combine the yolk, water, and pigment and add a little more water to dilute (about half yolk and half water). You will find that some pigments mix in more easily than others. For example, ultramarine blue combines with the yolk very easily, whereas white may need to be ground in a pestle and mortar first.

USING EGG TEMPERA

Egg tempera is slightly glutinous in consistency and dries quite quickly, after which it becomes very stable. It cannot be painted on with sweeps of the brush, instead you have to progress across the required area with small, thin, interlocking parallel strokes. This produces an area of even, translucent color through which the vellum shines, adding greatly to the richness of the hue.

More color can be added in successive layers until the required intensity of color is reached. Mistakes are more easily rectified with egg tempera than with other media because the layer of paint remains on the surface and can be removed by gentle scraping with a knife.

Outlining and highlighting techniques are similar to those described in the gouache section (page 21).

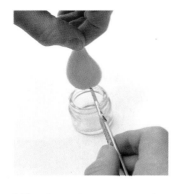

1 To mix egg tempera, separate the egg yolk from the white by picking up the sac between thumb and index finger. Dry it on some tissues. Then, holding it over a clean container, nick the sac with a craft knife.

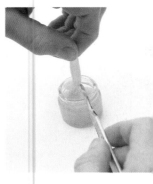

2 Hold the sac so that the yolk drops into the container. You can use a knife to ease out the yolk but leave the sac intact.

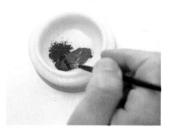

3 Spoon a little ground pigment into a dish and then add a few drops of water to dilute it. Add more water if necessary.

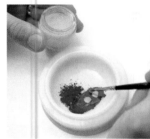

4 Add the egg yolk using a clean brush. Try to keep the ratio of egg yolk to water about half and half.

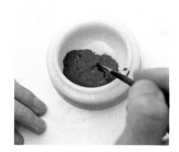

5 Use a different brush for mixing. Continue to add water and egg yolk until you have achieved the right consistency.

6 Paint on the tempera with a fine brush using small, interlocking parallel strokes. You can build up the strength of color by adding more layers.

Watercolor

Used for their translucent quality, watercolors can be bought in tubes, jars (shown above and below), or cakes. If you can afford it, buy high-quality artists' colors, which have a greater percentage of pigment and higher permanency. You can start with the same palette as for gouache (page 20), but without the whites.

Build up a rich density of color by superimposing controlled washes of dilute paint from light to dark. For the purpose of illuminating letters, most of the color will be applied wet on dry, allowing the first layer to dry before applying another.

Inks

Two different types of ink have been used for the projects in this book: waterproof ink for outlining a design before painting, and permanent ink for calligraphy. It is worth buying high-quality inks. Waterproof ink can be difficult when you are tracing an intricate fine line as it tends to clog up the pen point. Shake the bottle before use, then dip in the point, touching the tip against the rim of the bottle as you take out to remove any excess ink.

Masking fluid

Masking fluid is used to conserve areas of white paper which can then be worked on at a later stage. It is usually yellow so that it can be seen on white paper. In the first project (pages 36-9), a general area of paper is reserved, but in later projects more precision is required. This will take practice as masking fluid is rather grainy and glutinous. Apply it using a fine, but old, brush, cleaning it immediately in warm, soapy water (a process not recommended for new brushes). Once superimposed washes are dry, gently remove the masking fluid with a soft, clean eraser.

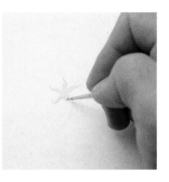

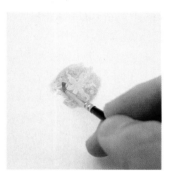

1 Apply the masking fluid with a fine, old brush. The yellow color allows you to see it against the white paper.

2 Paint over the masked area with a dilute wash of color. The paint will not adhere to the masking fluid.

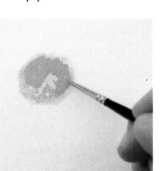

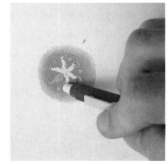

3 Add more opaque color. As it dries, the paint will recede away from the masking fluid.

4 Once the paint is dry, remove the masking fluid with a soft, clean eraser. Rub very gently.

23

GILDING TECHNIQUES

For the illuminator, gilding is the tightrope act, the skill which causes the audience to gasp with amazement. Indeed, it can be a difficult and sometimes laborious process. But, as we show you here and in more detail in the step-by-step demonstrations, there are various types of gilding, some of which produce excellent results without too many difficulties. In this section, we consider traditional gilding techniques and look at some of the more modern products available which can make gilding cheaper and more accessible.

Powdered or Shell Gold

The finish of powdered gold is quite dull, but it has a slight textured effect which contrasts well with the brilliance and smoothness of gold leaf. It is usually sold in small quantities by weight, then combined with gum arabic, diluted with water, and applied with a brush or pen. Alternately, you can buy it already combined in a small, dried tablet which can be dissolved in water. This is known as "shell" gold because the tablets used to be dried in one half of a mussel shell.

Powdered gold is applied with a brush and, therefore, is easier to control than gold leaf. It is often used for tiny details or on top of a colored pigment – two examples where using gold leaf would be difficult. The problem with powdered gold, however, is that the granules of gold are suspended in a medium, so you need to learn to control the flow, making sure that once the medium has evaporated, you are left with the correct concentration of gold. Keep stirring the paint, so that the gold is evenly distributed, and use it sparingly. You will need to judge carefully how much to dilute it: if the gold is too dry, it can clog up the pen point or brush; too diluted and it will not show.

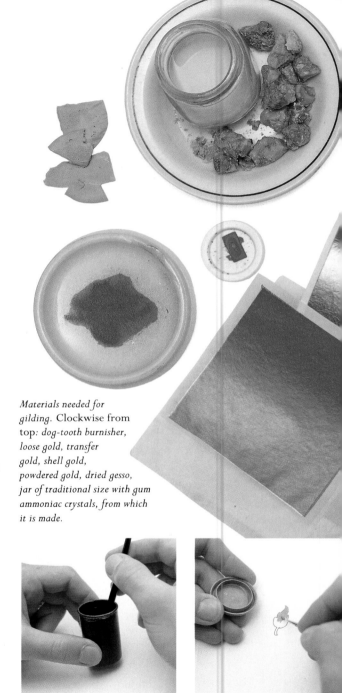

Materials needed for gilding. Clockwise from top: *dog-tooth burnisher, loose gold, transfer gold, shell gold, powdered gold, dried gesso, jar of traditional size with gum ammoniac crystals, from which it is made.*

1 Use a non-transparent container to prepare powdered gold (see top of page 25 for details). Stir it well before use.

2 When smoothly combined, apply the paint, keeping the brush moving. Dip only the tip into the gold or it will clog up.

USING POWDERED GOLD

To use powdered gold, you need to combine it with gum arabic. Place half a gram of powdered gold in a small, preferably dark, container – this container must not be transparent. A black plastic film cup is perfect, but an egg cup with plastic wrap to cover it would do. Add 20 drops of gum arabic from a brush and just enough distilled water to stir into a sludge. Now fill the pot with water and stir for another fifteen minutes. Leave overnight, then pour off the water into a similar pot – this will be used for cleaning your brush. When you have used all the gold in the first pot, refill it with the water from the second pot. By repeatedly doing this, you use the gold which accumulates in the bottom of the pots each time, preventing wastage of the valuable gold powder.

Powdered gold in this form can be applied straight onto paper or vellum. Once it has dried completely, it should be burnished to improve its reflective quality and to make it a little smoother.

Gold Leaf

Gilding with very delicate leaves of gold is a highly skilled technique and will take some practice, but it is worth persevering – the results can be stunning.

There are two types of gold leaf – transfer gold and loose gold. Transfer gold is purchased in small, single sheets with the gold affixed to a backing sheet, just like a transfer. It is easier to handle than loose gold and is often transferred directly onto the binder with loose gold laid over the top.

Loose gold comes in books of 25 leaves, single or double thickness, with each leaf sandwiched between sheets of backing paper. Gold leaf is extremely thin and delicate, blowing away or disintegrating at a careless touch, and it will take a while to get used to handling it.

Both types of gold leaf will adhere to paper or vellum only with the help of a layer of binder – size, which is flat (page 26), or gesso, which is raised (pages 26-9). Gold leaf will also stick to itself and to paint.

Silver Leaf

Silver leaf comes in books like gold leaf, both loose and transfer, and behaves like it in all respects except one – it does not stick to itself. Consequently, silver leaf has to be laid in a single layer, which makes it more difficult to apply, but the effect, as you will see in the project on pages 134-7, is worth the risk involved.

Silver leaf will tarnish over the years, so it is best to keep it framed or in a book which is normally kept closed. In cases where tarnishing would be completely unacceptable, substitute aluminum or white gold.

Leave the gold to dry for at least half an hour. Test before burnishing with a dog-tooth burnisher in a circular motion.

4 Burnishing improves the reflective quality of powdered gold and helps to give the surface a smooth finish.

Techniques

TRADITIONAL SIZE

The traditional size used for flat gilding with gold leaf is made with gum ammoniac crystals which are purchased in lumps. To make size, cover a tablespoon of gum in a jar with hot water, leave overnight, and then strain through a fine mesh (a pair of nylon hose works well) to remove any impurities. Tint it with watercolor or food coloring and apply with an old brush to areas you wish to gild. Wash your brush with hot water as soon as possible or it will harden.

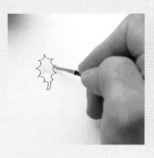 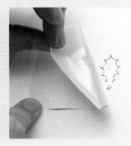

1 Apply size with an old brush. Where you paint the size, the gold leaf will adhere, so proceed carefully.

2 Leave it to dry for half an hour and then apply a sheet of gold, pressing it into the size.

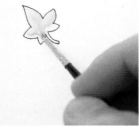 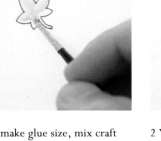

1 To make glue size, mix craft glue half and half with water and apply using an old brush. The first layer will be absorbed by the paper, so apply generously. Allow to dry for half an hour.

2 You can build up size to form a shape in relief, applying a new layer once the previous one is dry. "Spoon" on the size, painting around the edges before filling in the center.

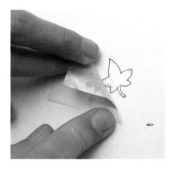 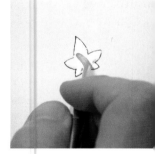

3 Apply the transfer gold, pressing it through the backing paper into the size. Size is tough and will accept quite a lot of pressure.

4 Burnish the gold with a dog-tooth burnisher, working carefully over the whole surface and along the edges. One layer of gold is enough with glue.

Glue size

Diluted white glue can also be used to bind gold leaf to paper or vellum. It can be used either flat or as a raised binder and, as you can see in the Romanesque and Early Gothic projects (pages 72-5 and 84-7), can produce very good results. Using glue size is also good practice for using gesso and will accustom you to handling and burnishing gold leaf. As glue only needs one layer of leaf, it is also less expensive to use.

You can purchase tubs of conservation-grade glue in specialist stores, but white glue can be found in any good stationery store – children's glue was used here. Make a mixture of half glue and half water, adding watercolor so that you can see it. Keep it thoroughly stirred, washing your brush now and then in hot water.

With glue size, you can build up your relief in layers, but allow each layer half an hour to dry. The first layer of size tends to soak into the paper, so spoon on the mixture and keep it flowing. Push the size around the edges of the shape, before filling in the center. When dry, apply the transfer gold, pressing through backing paper. Burnish with a dog-tooth burnisher.

GESSO

he combination of leaf gold and gesso is almost
iraculous. No photographic reproduction can
dequately show the brilliant effect of raised gesso.

You will probably want to buy your gesso ready-made
first; it can be purchased in jars of liquid yellow
edium from specialist calligraphers' stores, but as you
in experience you may wish to make your own. Gesso
kes a long time to make and involves using white lead,
hich needs careful handling, but it is much cheaper
d one batch will last for many years. Making your
vn gesso also means that you can adjust the
nstituents until the mixture is just right. You will
ed the following ingredients:

- *12 parts of slaked plaster (dental grade)*
- *4 parts white lead (CAUTION: this is a hazardous material, wear a mask and take care not to inhale)*
- *1½ parts of fish glue (seccotine)*
- *2 parts of sugar (crystals or coffee sugar)*
- *A pinch of Armenian bole (to color the gesso — use only a little, too much creates impurities)*

Slaking plaster

culptors' suppliers sometimes stock slaked plaster;
ut it is possible to slake it yourself. This takes a little
ne to master but you quickly get into the rhythm of
. Stage one: take about 1 lb of fine dental plaster and
it it in a plastic bucket and fill with water. Stir with a
ooden spoon for one hour to remove its setting
pability. Stage two: leave for a day, then pour off
xcess water and re-fill with fresh water. Stir for ten
inutes. Repeat stage two every day for a week, then
ery other day for three weeks. After this, you can use
in the above recipe for gesso or dry it for future use.

Mixing gesso

Using a pestle and mortar, grind the dry ingredients
together for fifteen minutes. Add the glue and enough
distilled water to bind it. Mix for forty-five minutes.

You can make either as much gesso as you need for
one project, or you can mix a large batch and dry it for
future use. To dry it, form the creamy mixture into
1-inch (2-centimeter) circles on a sheet of thick
cellophane. When these "cakes" are dry but still soft,
cut them into smaller pieces and dry them thoroughly.
Store in a rust-proof container.

To use the dried gesso, break off a small portion,
crush the particles in a small pot or cup with a little
distilled water. Allow to soak, then stir until smooth.

If the gesso is bubbly, it can be a serious problem.
Modern illuminators still follow the age-old practice
of touching a little earwax into the gesso to burst the
bubbles. You could also try pricking bubbles with a pin.

Applying gesso

Gesso is very sensitive to humidity so, if possible, work
in a room without drafts and which is not too dry or too
hot. You need to work quickly, as gesso can only be
worked on once. The consistency of the gesso is very
important: it should be stiff enough to retain a shape
but thin enough to handle. Add more distilled water if
necessary and keep stirring it throughout the operation.

Rather than painting on gesso, it is best to "spoon" it
on. This means scooping up the gesso onto a brush and
then tipping it into the center of the area you wish to
cover. Tease the gesso into the shape you want, pushing
it with the brush tip, and add more by pressing it in
along the shape with vertical jabs of the brush. Build up
the required dome shape in this way, avoiding cliff-like
edges and a flat top. Do not apply the gesso in layers,
but use the wet-in-wet technique.

All this takes practice, so start with a small uncomplicated shape, and repeat it across a page. Don't be disheartened if it doesn't work every time: the successful application of gesso depends on a lot of factors being right.

It is best to leave gesso to dry overnight. It dries hard and you can then smooth out any imperfections, or remodel the contours, by scraping it gently with a flat blade. Don't scrape aggressively; let the weight of the knife carry the blade over the gesso.

Finally, burnish it gently with a dog-tooth burnisher. This will help moisture to condense on the surface.

HANDLING THE LEAF

You will find gold leaf quite difficult to handle at first, so use these few helpful guidelines:

Always hold the book by its spine between the index and center fingers of your secondary hand with the "pages" hanging down – this will stop the gold from folding into the spine of the book. Use your thumb and index finger to hold the book open.

Always use sharp scissors to cut out the shape required for gilding with your primary hand. If you leave a tiny section uncut, take the cut portion of leaf with its backing paper between thumb and index finger and pull gently.

APPLYING GOLD LEAF

Before you apply the gold leaf, you need to moisten the binder – size, gesso, or glue – so that the gold adheres to it. This is done by breathing onto it, either directly or through a paper tube to concentrate the moisture – don't be tempted to use a plastic straw as the air will condense and drip out onto your work.

Lay the gold leaf onto the binder. You may find it easier to use tweezers than your fingers. If the gold leaf blows off course, try picking it up or use a brush to tease it back into place.

BINDING AND BURNISHING GOLD LEAF

Once the gold leaf is in position, press it onto the binder. With gum ammoniac size, lay transfer gold over the sized area first. Use your fingers to press hard through the backing paper and try not to twist as you press or the gold will crease. Make sure the gol has adhered by lifting up the corner of the backing sheet, then use a dog-tooth burnisher to burnish the gold through glassine paper (sometimes known as crystal parchment). This indirect method of burnishin stops the gum ammoniac size from softening and ruining your gilding. If the gilding is patchy, breathe o the patch again. Then re-apply the gold leaf and re-burnish. Gently brush away any excess gold from the surface, edges and corners using a soft brush.

With gesso it is usual to build up the layers of gold, starting with transfer gold and adding a layer or two of double-thickness gold leaf. When you lay on the lea gold, take care not to press too hard or you may break up the gesso or craze the surface. The moisture from your breath will have softened the gesso, so leave it fo half an hour to harden again. Then test a corner to check that it has reset before burnishing, first through glassine to make sure. You can then burnish directly onto the gold, continuing to add layers until full brilliance is achieved. Finally, use a pointed pencil burnisher to "cut" away the gold from around the edge of the gesso. Take care not to press into the gesso or y will get an indented line. Brush away any excess gold using a soft brush.

With glue, one sheet of transfer gold will be enoug laid on in the same way as the other types of size. You will need to press the gold hard into the binder, but there is no fear of breaking up the glue binder as there with gesso. Burnish directly onto the transfer gold immediately. You can burnish hard as it is very strong. Again, brush away excess gold.

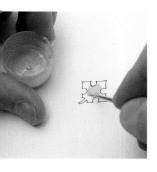

Apply the gesso, "spooning" it
th the brush into the center of
e shape. Any bubbles can be
icked with a pin.

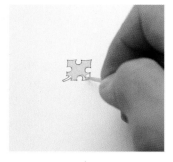

2 Tease the gesso into the
required shape, dragging it
across the surface and pushing it
into the edges with a brush.

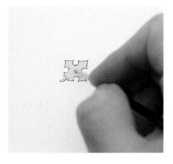

3 While it is still wet, add more
gesso to the center of the shape,
encouraging it to disperse with a
vertical jabbing motion.

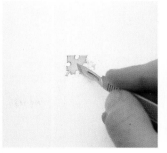

4 Leave overnight to dry. To
perfect the shape, scrape gently
with a scalpel, allowing the
weight of it to do the work.

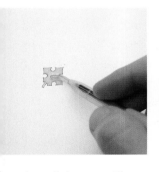

Now burnish the gesso. This
ll smooth it and will also help
e moisture to condense on its
rface ready for burnishing.

6 To get plenty of moisture onto
the surface of the gesso, breathe
hard through a tube of paper
secured with masking tape.

7 Quickly lay on a sheet of
transfer gold and press into the
gesso through backing paper.
Let gesso reset for half an hour
before burnishing, first through
glassine paper, and then directly.

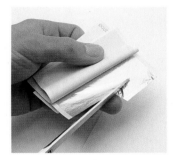

8 A layer of double-thickness
loose gold over the transfer gold
will build up the brilliance of the
gilding. Hold the book as shown
and cut a piece of the right size
with sharp scissors.

Breathe on the shape again and,
lding the piece of gold with its
cking paper with thumb and
dex finger, lay it carefully over
e shape and press on through
e backing paper.

10 Burnish directly onto the
loose gold with a dog-tooth
burnisher. Then, working
through glassine, use a pencil
burnisher to cut away the gold
around the edges.

11 Remove the excess gold leaf
with a soft brush, making sure
that you work into all corners
using the corner of the brush.

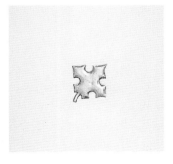

12 Add more layers of loose gold
until full brilliance is achieved.
The raised gesso catches the
light, causing the gold to flicker.

Gouache Gold

It would be foolish to ignore the new family of golds produced in gouache lines. In the past, gouache gold was considered to be very second-rate, but new developments have produced a possible substitute for powdered gold. It is similar to shell gold in that you need to adjust the dilution of the paint to achieve a good result, and likewise, you need to keep an even flow of paint and take care not to overwork it. You can burnish gouache gold, too, but this is more to smooth it than to make it more reflective. You can see the effectiveness of gold gouache in the first project (pages 36-9).

PREPARING YOUR WORK

Time spent on preparation is always worthwhile, even if you are only copying an initial. In each project, the four pages that follow the step-by-step photographs show the sketches and color tests made by the artist before he started work. They also show a variety of sources which serve to generate new ideas for adapting illuminations, and, as shown on these "sketchbook" pages, there is no limit to the ways in which you can develop a source for your own purposes.

Finding a Source

Photographs of illuminated manuscripts are invaluable as sources for copying and adapting illuminated letters for your own use. In reproductions, however, detail is often blurred or lost and color distorted, so look at as many original manuscripts as you can — only then can you appreciate their full beauty as well as study technical details, such as how the paint was applied, what the shape of the gesso base was for the gilding, and any subtle variations in color and tone.

To create the illuminated initials in this book, the artist referred to photographs of historical manuscripts, and researched flowers and animals from reference books (right).

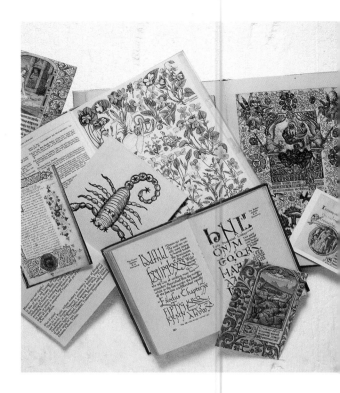

Sketching

The most common form of adaptation is from one initial letter to another, from "A" to "C", for example. This may seem quite simple, but you will need to try out the new arrangement, adapting any interlacing or knotwork within or around the new shape. You are looking for a rhythm and balance in your design which will only come from trial and error, and a few rough sketches on rough paper or layout paper with a pencil, colored with felt-tips or crayons, will give you a good idea of how it will look.

When you are satisfied with your design, draw it carefully on a piece of rough paper, ready for tracing. It is better to do it this way so that the paper or vellum you will illuminate is handled as little as possible. Try out your color mixes on this rough paper, using paints of your choice. This will give you a chance to make sure that your color masses are balanced.

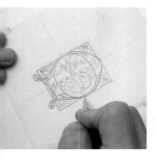

When you have traced your
…sign, turn the tracing paper
…er and draw around the image
… the wrong side.

2 Place the tracing on the paper
or vellum, matching the bearing
lines, and fix with masking tape.
Retrace the design.

Tracing

…raw two bearing lines at right angles to each other
… the center of the initial. Anchor the tracing paper
…ith masking tape and trace the bearing lines to make
…re you keep the tracing straight. Then, using a sharp
…B pencil, trace lightly around the design on the
…verse side. Draw up very faint bearing lines on your
…od paper or vellum, attach the tracing paper with
…asking tape with the bearing lines aligned, and
…e a fine hard pencil to trace through.

Enlarging

…here are various ways of enlarging an initial. The
…siest way is with a photocopier, which is particularly
…eful if you want to try out a variety of different sizes.
… The traditional method is to square up the original
…d then transfer the design onto a larger grid, square-
…-square. If you don't want to mark the original, you
…n draw a grid of squares to fit over the source on
…sheet of acetate or tracing paper. Measure a larger grid
…r the size you want onto a piece of layout or tracing
…per and carefully transfer the design, taking one
…uare at a time. This can then be traced onto your
…od paper or vellum.

ORDER OF WORK

Y ou will see from the projects in this book that the
order of work cannot always be the same. It
depends on various practical factors which you will
need to consider before you start. The usual order is:
1. Initial outlining in waterproof ink;
2. Application of masking fluid, binder, size, or gesso;
3. Gilding;
4. Burnishing;
5. Painting;
6. Outlining or re-establishing original outline;
7. Highlighting.
The use of masking fluid in the project on pages 142-7
made this order impossible because of the possibility of
the gold adhering to the paint. In this case, therefore,
the artist chose to apply the paint before the loose gold.

WORK STATION

E ven if you have been working on illuminating for
years, it is worth reassessing your "work station"
every now and then. The following are essential:
1. A good light, coming from above and in front of your
work without shining into your eyes, to your left if you
are right-handed, to your right if you are left-handed,
so that there is no shadow.
2. A good chair, preferably
adjustable, of the right height,
which supports the back.
3. A table or a drawing board
held at an angle and supported
on your knees. If you spend a
lot of time on calligraphy and
illumination, you might consider
investing in a designer's
adjustable drawing board.

*Working at an
adjustable drawing
board, the artist
finds everything is
close at hand
(below).*

The
PROJECTS

CELTIC

CELTIC ILLUMINATION, based on the Irish script, is decorated sometimes with a flurry of interlaced spirals, sometimes with fantastic beasts lashed together in a stylized pattern or with animal-head finials, staring open-mouthed. You will find repeated motifs which make up the vocabulary of this style, with romantic names, such as divergent trumpets, trefoils, the lion's paw motif, and the swash knot.

Another important feature of Celtic illumination is the creation of a rosy glow around the initial letters with rows of red dots. These dots used to be painted in red lead – minium – which gave its name to the word "miniature." These borders of dots soften the decorated letters, giving them a shadow which appears to lift them from the page.

The most complicated examples of these Celtic texts are memorials to the dedication and painstaking diligence of their creators. Yet, as you will see here, there is enormous grace and beauty in much more simple examples of this period.

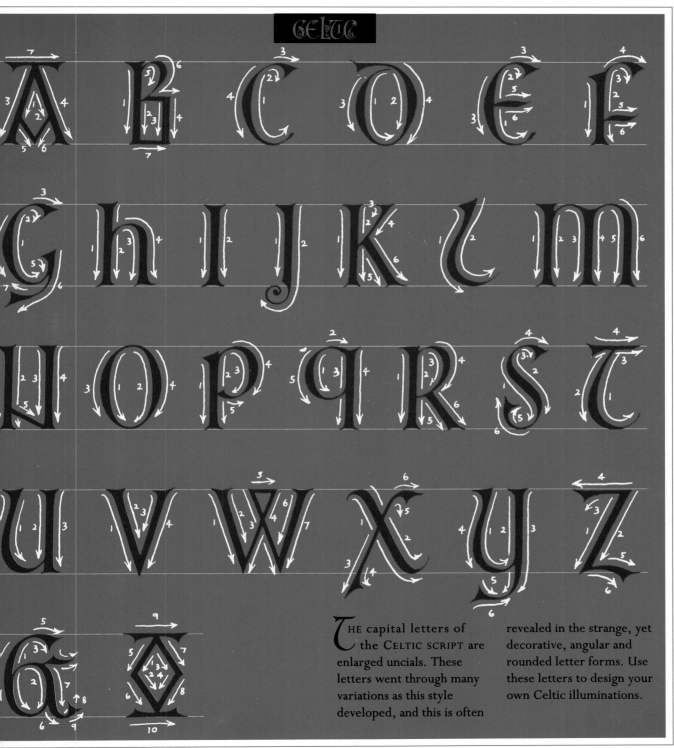

The capitals of the Celtic script may be painted with a brush or written with two parallel strokes of a pen to form thicker stems. The pen point should be fine and horizontal.

The letters are based on an upright, slightly oval "O" which dictates the width of the other letters. Space the letters evenly by calculating a balanced space between each line or curve.

Use the corner of the pen point to form the wedged serifs, which may be extended to form spirals, interlace, or animal heads.

THE capital letters of the CELTIC SCRIPT are enlarged uncials. These letters went through many variations as this style developed, and this is often revealed in the strange, yet decorative, angular and rounded letter forms. Use these letters to design your own Celtic illuminations.

THE LINDISFARNE GOSPELS

The *Lindisfarne Gospels* were created in 698 in the island monastery on the Northumbrian coast to commemorate the removal of the remains of Cuthbert, former bishop of Lindisfarne, to another resting place. The work is regarded with such awe that the monks who worked on it, who usually remained anonymous, have found a place in history: Eadfrith, the scribe and illuminator, and Ethilwald, the binder.

On the introductory page to each Gospel, the initial letter is richly ornamented with spiral interlacing, knotwork, and stylized patterns of birds and beasts — birds were particularly popular. The first words of the text are decorated more simply. Dividing the Gospels is a page of abstract design, known as the carpet page, as it is shaped and decorated like an oriental rug.

Colored pigments were used, including a rich yellow which was used instead of gold. These vellum pages glow with the outline of red dots — as many as ten thousand, six hundred have been counted on one page — which may have been painted at a rate of thirty dots per minute.

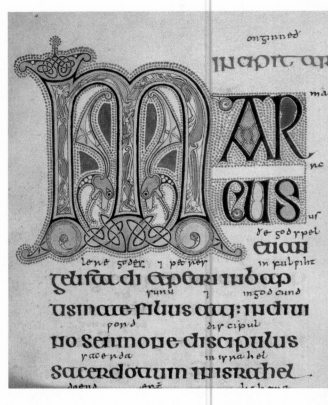

INITIAL "M" FROM THE LINDISFARNE GOSPELS
late 7th century

YOU WILL NEED

- Pencil
- Soft pencil eraser
- Colored pencils or felt tips (for colored rough)
- Sketching paper
- Tracing paper
- Watercolor paper
- Brushes — Sable 1,0,00
- Masking fluid
- Dog-tooth burnisher

GOUACHE PAINTS:
- Vandyke brown
- Lamp black
- Winsor blue
- Lemon yellow
- Zinc white
- Scarlet lake
- Purple lake
- Imitation gold

Paint on the masking fluid.

Reserve enough paper to work on later.

...ge between ...erlace and ...line

Edges can be cleaned up later.

Color is not too flat

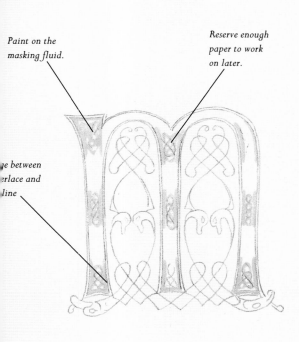

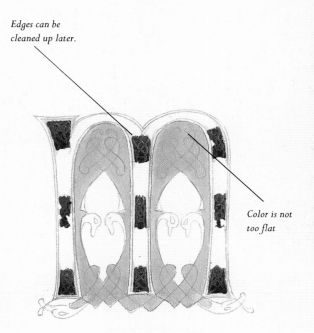

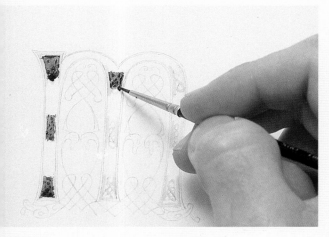

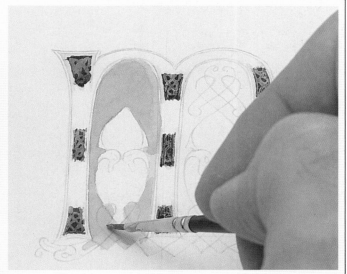

Work up a colored rough and trace it on a piece of ...uarelle watercolour paper. ...e masking fluid to reserve the ...icate interlace and the edge ...ween the interlace and the ...ter outline. With a sable 1 ...sh, carefully paint around the interlacing with a thin watery wash of Vandyke brown and lamp black gouache. Don't scrub the paint on, but add the color in many thin layers until you have achieved sufficient depth.

2 For the areas of green, use a mix of Winsor blue, lemon yellow, and zinc white. Use a diluted layer of color to moisten the area, then flood in more opaque color. Paint around the outline of the shape first and then fill in the center.

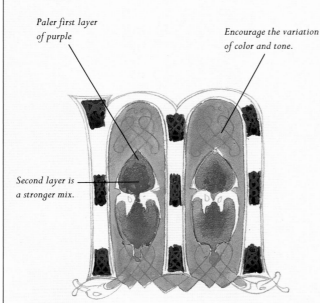

*Paler first layer
of purple*

*Encourage the variation
of color and tone.*

*Second layer is
a stronger mix.*

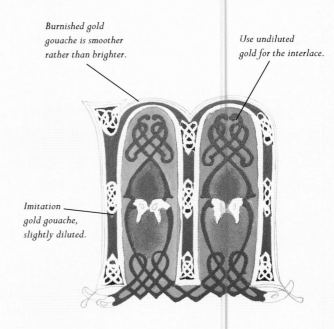

*Burnished gold
gouache is smoother
rather than brighter.*

*Use undiluted
gold for the interlace.*

*Imitation
gold gouache,
slightly diluted.*

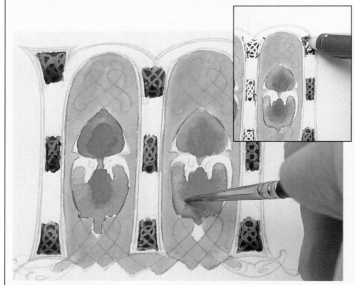

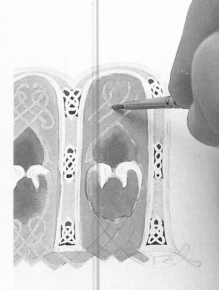

3 The purple is a mix of scarlet and purple lake with zinc white. Again, wash the area first, then flood in an opaque layer of purple. Apply a second layer of a stronger mix into the center. Once the paint is dry, gently rub away the masking fluid with a soft eraser, working on small areas at a time (inset).

4 Add the areas of gold with a sable 0 brush, using slightly diluted imitation gold gouache. Lay it on smoothly in clean strokes – the less you work it, the better. Wash any areas of gold with water and then flood in the gold. For the interlace, use the gold undiluted to cover the green. Once it is dry, burnish the gold with a pointed dog-tooth burnisher (see Tip).

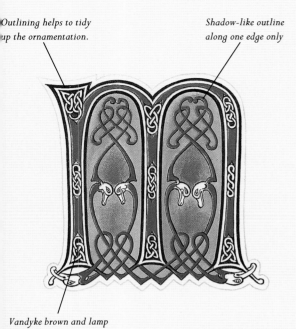

Outlining helps to tidy up the ornamentation.

Shadow-like outline along one edge only

Vandyke brown and lamp black gouache mix outline

THE FINISHED LETTER

You can see how the line of red dots softens the outline of the initial, creating a shadow-like blurring of the edge which lifts the initial from the page. In the original *Lindisfarne Gospels*, the spaces between letters on the opening page of each gospel are filled with rows of these red dots.

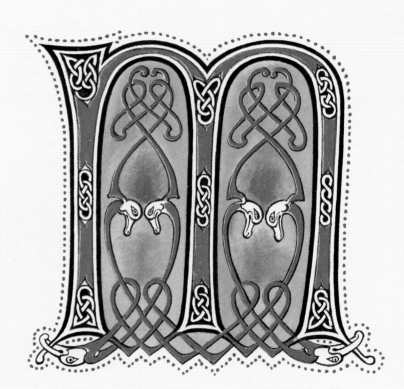

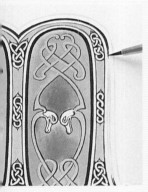

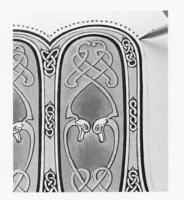

Fill in the thicker outline of the letter and the fine inner ... clean up the blocks of ...erlace and then outline the ...d interlace, along one edge ...y – to look like a shadow. ...e a fine sable 00 or 000 brush ...th a good point and the ...ginal brown-black mix, ...uted very slightly.

6 Finally, add the border of red dots. Use a sable 1 brush or a short spotter and keep the pressure even. With patience, you will learn to predict when the brush needs loading. You will find that you soon develop a rhythm. Keep the dots small, although mistakes can be cleaned with permanent white.

This Celtic "O" from the LINDISFARNE GOSPELS (*right*) is decorated in a typical fashion with birds and ornate spirals. Such motifs could be used on any letter based on an oval, such as "D" or "G."

This sketch of a Celtic "D" (*right*) shows some ideas for interlacing in the center field as well as the tongue of the lion's head terminal. *Below*, you can see interlacing at the end of a letter, copied from the LINDISFARNE GOSPELS.

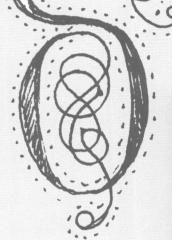

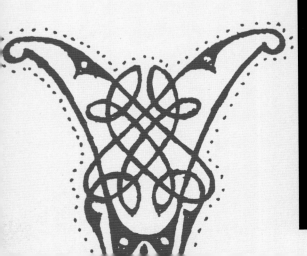

In these sketchbook pages, decoration from the Celtic period of illumination is gathered together to help you form an idea of the Celtic style and to give you some ideas to plunder for your own adaptations. Images have been included to show you the range of imaginative motifs which make up the Celtic style and to inspire you to take up your pencil, pen or brush and try out some ideas. Remember, you can take part of one design and combine it with part of another to make it fit the initial you have chosen. Use a photocopier to enlarge motifs, and bear in mind that you can alter the scale of a motif to make it fit into the empty field of a letter, for example the center of an "O." Also included on these pages are any relevant workings for the projects in this section, here the Celtic "M" from the *Lindisfarne Gospels*. It is only by sketching your ideas that you will get to know what is possible and works well within the Celtic style.

uch an immaculate example based on Celtic design (*below*) could be used within a letter or as part of the layout of a page of text.

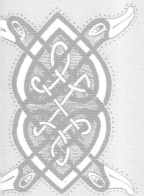

Below, two fish with intertwined tails decorate this Celtic "H."

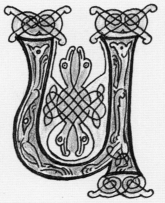

When you copy an initial, such as this interlaced "U" sketched from the LINDISFARNE GOSPELS (*above*), you can see how it will look in isolation.

A typical Celtic "A" (*below*), decorated with spirals, interlace, and knotwork.

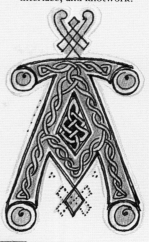

CELTIC

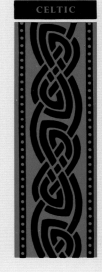

This sketch shows the interlace pattern within the arches of the Celtic "M" (*right*), as previously demonstrated.

To preserve the beauty of the calligraphy of the Celtic "M" in the project (*above*), the letter was traced from this example and re-created with pen and ink. You could enlarge such a letter on a photocopier.

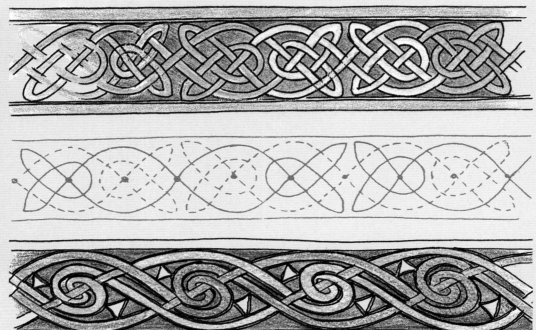

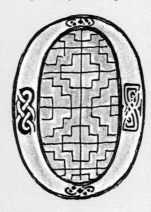

On these sketchbook pages, we look at some ideas for decorative borders, combined with calligraphy. Most of the borders have a repeated pattern which can be expanded or contracted to fit the space you have in mind. The *Lindisfarne Gospels* had borders around part of the page, with the main illuminated initial sometimes spreading across and incorporating the pattern of the left-hand border (see page 36). Spacing the calligraphy and illumination on the page is an art in itself – it is a good idea to try out some sketches to see how the finished work will look on the page. Use letters from the Celtic half-uncial alphabet on the opposite page to complete words started with your Celtic illuminated initial. A border can be used to contain the text or to give it some sense of order.

Above, the top border is from the LINDISFARNE GOSPELS. Below it, you can see how the artist begins with equally spaced points which are then connected with curves. The third border (*above*) is a variation from the BOOK OF DURROW with the rough working of this pattern (*right*).

The geometric pattern decorating the void of this "O" (*above*) is often found in enamel work of the time.

celtic half-uncials

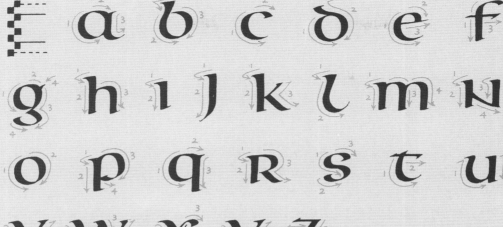

CELTIC

Base your illuminated initials on these Celtic half-uncials (*above, left*), decorating them on their own or combining them with the enlarged uncials on page 35.

Celtic minuscule numerals (*left*).

Above, different patterns of knotwork are shown within sections of letters. These show how the patterns can be used, in expanded or contracted form, to fill a space.

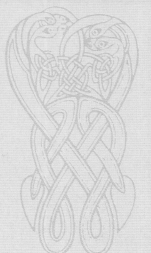

Try out some ideas for your page layout: writing around in a circle (*below, left*); enclosing the script with a border of decorated capitals (*above, left*); a rather more practical, than decorative, arrangement using a Celtic two-column layout (*above*).

In order to balance an illuminated letter at the start of a block of text, it is useful to have a decorated panel such as this one (*left*) at the end.

43

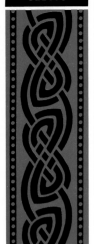

At first glance, you might not notice the drama of the action in this monogram "TU." Entwined in mortal combat are a cat and a bird, perhaps a dove. Such flights of fancy are typical of the imaginative decoration of the lesser initials of the *Book of Kells,* now at Trinity College, Dublin. Discovered in the twelfth century in Ireland, this book is thought to have been created in the north of England between 600-900 A.D.

The order in which you need to work on a project needs careful consideration. For example, gold is usually laid down first to avoid disturbing the gouache during burnishing; here, however, gold is used at the end. By showing it in step-by-step stages, what might appear at first to be a task beyond the capabilities of a beginner is shown to be viable.

The artist decided to add the letters "n" and "c" in this case, as they were an integral part of the design and the balance of the initial was upset without them. The finished letter would make a special present or greeting card for very little cost.

INITIALS "TU" FROM THE BOOK OF KELLS
7th–9th century

YOU WILL NEED

- Pencil
- Tracing paper
- Heavy watercolor paper
- Calligraphy pen
- $1\frac{1}{2}$ point
- Non-waterproof ink
- Brushes – Sable 1,0,00

GOUACHE PAINTS

- Imitation gold
- Ultramarine blue
- Zinc white
- Cerulean blue
- Winsor blue
- Alizarin crimson
- Lemon yellow
- Vandyke brown
- Lamp black

*Tracing held down
with masking tape*

*Tracing line
followed with
great care*

*Adding "n" and "c"
gives balance to
the design.*

*Trefoils formed
with three circles
of paint*

*Layers of gouache
added until required
density is reached*

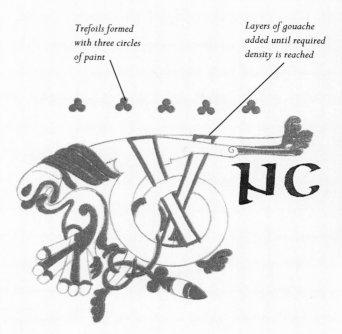

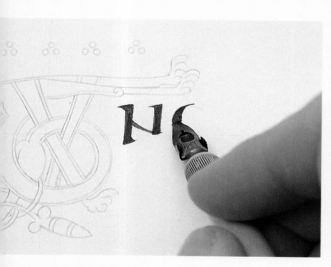

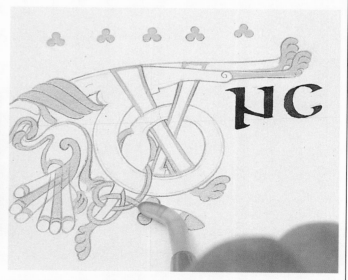

Before you begin this Celtic illumination, complete the word "tunc," adding "n" and "c" with a calligraphy pen with a 1½ point. Use India ink and practice with the pen first on a piece of similar paper. Use the corner of the point to form the wedged serifs. Calculate the spacing of the letters before you start making pencilled guidelines.

2 Paint on the gold gouache, referring carefully to the source. Once it is quite dry, burnish the gold gently with a dog-tooth burnisher, pulling it over the paint rather than rubbing.

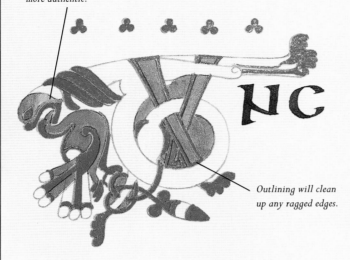

Blue wash over the head of the cat is varied to look more authentic.

Outlining will clean up any ragged edges.

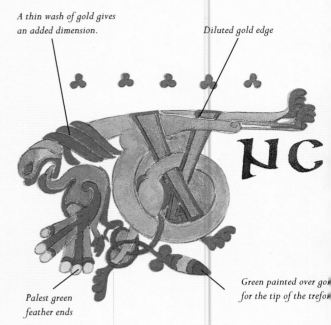

A thin wash of gold gives an added dimension.

Diluted gold edge

Palest green feather ends

Green painted over gol for the tip of the trefor

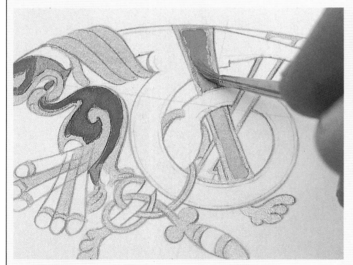

3 Add the flat color next, with a sable 0 or 1 brush. The blue is a mix of ultramarine blue, zinc white, and a touch of cerulean. Wash the area first with a medium blue, then add more opaque color wet-in-wet. Once the blue is dry, add the red, a mix of alizarin crimson and white, in the same way.

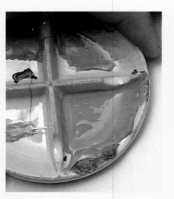

4 You can see the different consistencies of the green (Winsor blue, lemon yellow, and zinc white) in the dish, with the thinner wash on the right and the more opaque mix on the left. Use a thin wash first, then add more opaque paint. Add white to the green for the feather ends.

5 Paint a line of diluted gol around the edge of the green. The gold needs to be thick enough not to disturb the green, yet thin enough for the green to show through. Try no to drag on the brush; move it quickly and lightly across the surface of the paint.

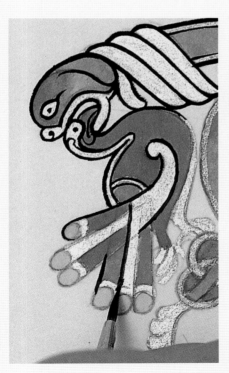

Gold edges the green.

wn-black outline
ns up the edges.

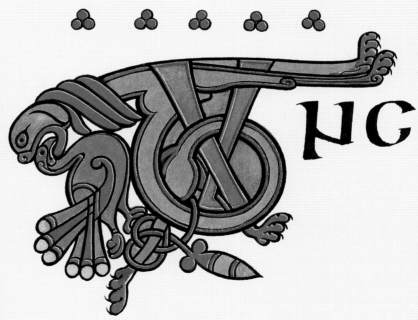

e original to
he outline
idth.

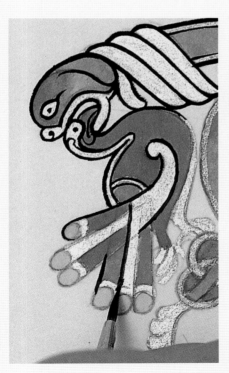

THE FINISHED LETTER

The result is both beautiful and amusing. The *Book of Kells* is full of such extraordinary designs for initials. If you cannot see the original, it is well worth seeking out a facsimile copy.

Don't worry if you have trouble with the outline at first; if it is not quite consistent in width, this merely adds to the character of your work — even the outline of the original has its variations. Outlining is basically just brush control, and this will get easier with practice.

For the outlining,
you will need a
k of Vandyke
wn and lamp black
a sable 00 brush
h a good point.
st your hand on a
ce of paper to
tect your work
to anchor the
d. The movement
the fingers, not
wrist. Paint in
rt strokes — one
ke forward, the
t one back over
first, then take the
t forward stroke
ond the first one
back to link with
end of the first.

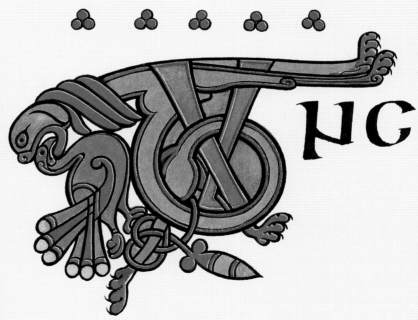

47

In these sketchbook pages, examples of Late Celtic decoration have been gathered together to illustrate the scope of this style. The *Lindisfarne Gospels*, c. 698, provide us with some ideas for letters decorated with animals, but it is the *Book of Kells*, written and decorated in the late eighth century, that is the real source of the most exotic animal decoration. The limbs, beaks, and tongues of these animals and birds spiral and knot into extraordinary contortions to fit the letter shapes. Let your imagination go and fill your sketchbook with all kinds of feathered birds and furry beasts.

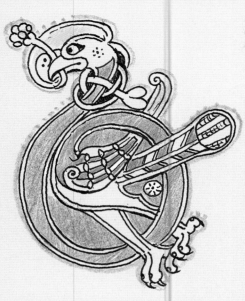

From the BOOK OF KELLS, this bird with uprooted plant (*above*) has a scatty appearance which is appealing. Note how the legs and wings cross before diverging side of the "B."

When you start on a project, make sure you base your illumination on well-penned initials. The letters "T" and "U" combined in the project, were traced from this graceful example from the BOOK OF KELLS (*above, right*).

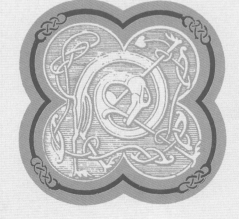

Animals can take any shape or form in Celtic illumination. *Left*, this duck-like animal spirals within an unusual shape.

This knot terminating a letter (*right*) is finished with two dogheads whose ears intertwine into yet another knot. The rubrication – the line of red dots around the outside – softens the hard outline.

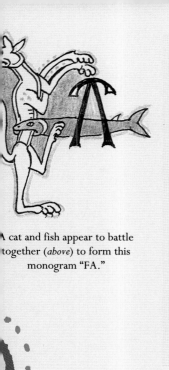

A cat and fish appear to battle together (*above*) to form this monogram "FA."

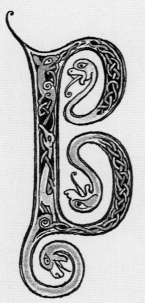

Serpent forms spiral and twist to form the letters "B" and "C" (*left and below, left*), while a clean design with birds from the LINDISFARNE GOSPELS forms the letter "E" (*below, right*).

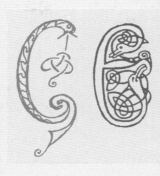

Right, look out for a detail such as this circular panel containing interlaced heads as it could be extracted to be used on its own or to decorate an "O" or "D."

CELTIC

Within the open fields of this "M" (*right*), cats appear to fight with strange beasts. If you follow from their duck-like beaks along the intertwining bodies, you will find they have what appear to be webbed front feet, back legs, and a tail.

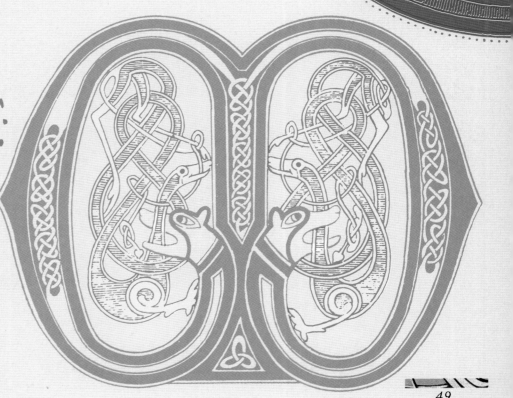

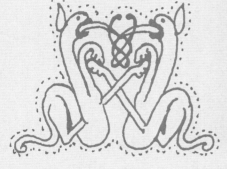

Borders around pages of text can be given decorated corners like this one (*above*) from the LINDISFARNE GOSPELS.

Above and right, a selection of borders from the LINDISFARNE GOSPELS, including a demonstration of the construction method (*far right*) for the border (*right*).

Do not be afraid to experiment and create your own images using the language of the Celtic style. You can combine part of one image with another as long as the resulting initial is graceful and balanced, in the style of the original. By this stage, you will probably begin to recognize the main motifs of the Celtic style – the uncial script decorated with combinations of knotwork, interlacing, and spirals; the contorted birds and beasts entwining around, between, and inside the letters; and finally, the rubrication of the illuminated letter with rows of tiny red dots which soften the outline of the initial.

Above, with their tongues interlaced, two cats confront each other to form the letter "V."

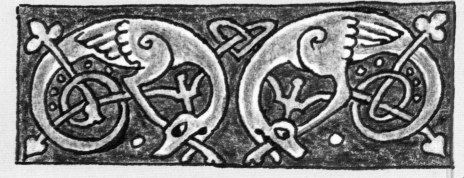

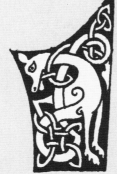

You can use a photocopier to enlarge images, such as this interlaced deer (*left*), which forms the serif of a letter.

Above and left, decorated panels can be adapted for use in a border or to decorate a page. Note also the cat-like border termination (*right*).

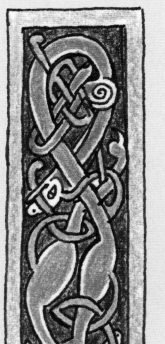

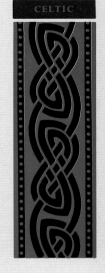

Some ideas for layouts: a centered layout with a panel at the base (*above, left*); two columns with balanced illumination (*above*); and horizontal Celtic layout (*left*).

The rubrication around this initial (*right*) is more complicated than the single line. Note, too, that the dots are of varying sizes. Draw a pencil line first to guide you.

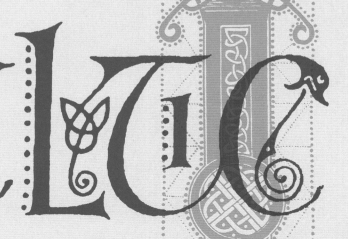

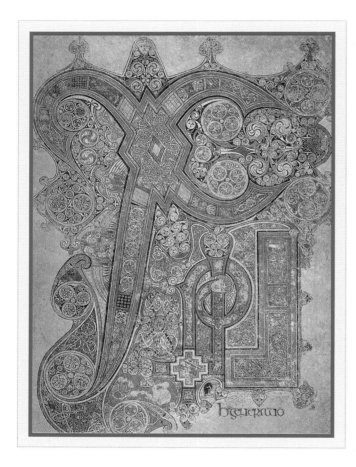

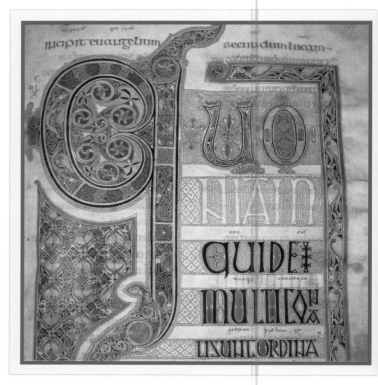

DETAIL FROM THE INITIAL PAGE OF ST. LUKE'S GOSPEL,
LINDISFARNE GOSPELS
7th century
This letter "Q" (*above*) is highly ornamented with animal interlace and spirals
Everywhere are the rubricated dots typical of Celtic illumination, surroundin
letters and forming patterns of their own.

INITIAL "M" BY HELEN WHITE
20th century
The decoration of this initial (*left*) has
been simplified and the colors altered,
but the essential Celtic character has
been retained.

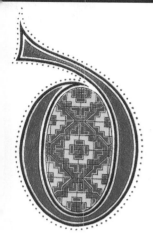

This adaptation of an uncial "D" (*above*) shows how geometric infilling may be adapted and colored. The dots around the letter give it an extra vitality and appear to lift it off the page.

The initial "N" dominates this page of illumination (*right*). The decoration incorporates geometric and interlaced animal designs which are echoed in the border. A panel of ornamental square-form letters is encased by the border and was a feature of these decorative pages.

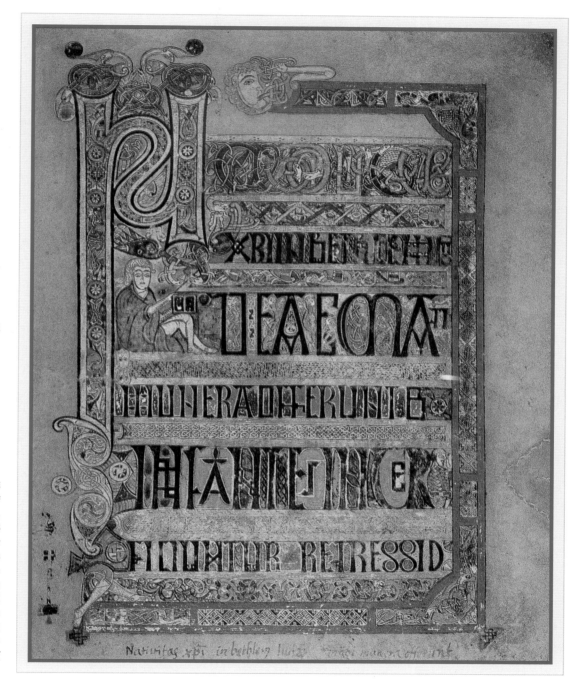

romanesque

ROMANESQUE emerged as the dominant style in Europe in the tenth, eleventh, and twelfth centuries. Illumination thrived in the hands of the Church, which expanded in wealth and power, spawning new orders and an impressive building program. There were many centers of excellence in illumination in England, France, and Germany.

The historiated initial, decorated with a narrative scene, became more popular during this period. Bibles and psalters, the most frequently illuminated books, tended to be larger with richly decorated initials. In Britain, many examples of illumination have survived from this period, faring better than other casualties of history and time, such as works in wood, stone, metal, ivory, embroidery, and stained glass, the latter often sources for designs used in illumination.

Later Anglo-Saxon illumination, of the late tenth and eleventh centuries, can be seen to reject Celtic influences and align instead with France and Germany and the more prevalent Romanesque style.

In Germany, the Renaissance, inspired by Charlemagne, was given new life a century later by Otto I, the first in a line of Ottos who gave their name to the Ottonian style. Illuminated letters of this period show a mixture of influences, including Carolingian, early Christian, and Byzantine, as well as the individual style of the Winchester School.

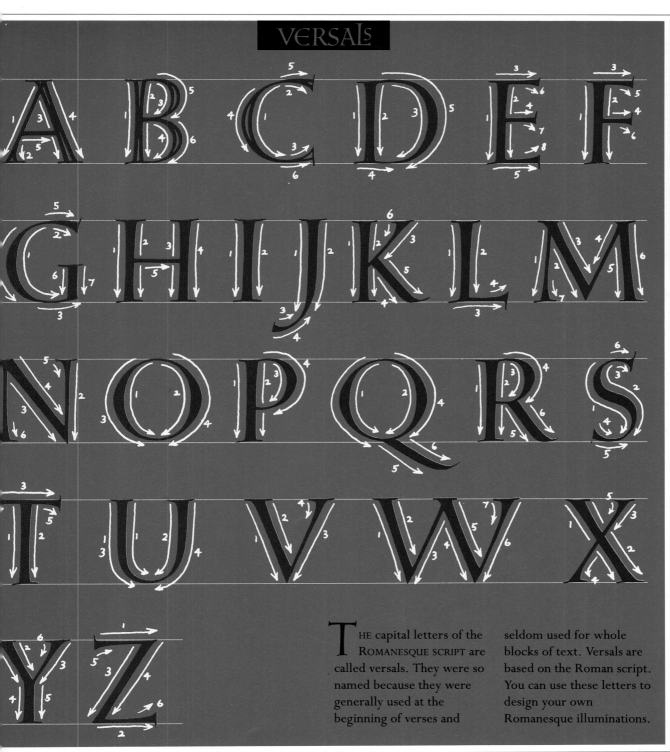

Versals are built up from compound strokes, with the pen held at a horizontal angle. Use double strokes for the thicker parts of the letter, usually the stem. The double strokes should start at one point width apart at the head, meet in the middle (see the "B"), then open out again at the base of the letter.

The shape of the letters is Roman, and based on a circular "O." The inside curves (counters) of the letters must be formed from parts of a circle.

THE capital letters of the ROMANESQUE SCRIPT are called versals. They were so named because they were generally used at the beginning of verses and seldom used for whole blocks of text. Versals are based on the Roman script. You can use these letters to design your own Romanesque illuminations.

THE GRIMBALD GOSPELS

The example from which this initial is adapted comes from the *Grimbald Gospels*, now in the British Library, which were completed in the early eleventh century. Grimbald of St. Bertin was founder and first Abbot of the New Minster at Winchester, England, at the time of Alfred the Great.

The initial is a late example of Anglo-Saxon illumination, which shows more classical Roman than Celtic influence, and is perhaps taken from Carolingian examples. This can be seen in the construction of the letter, the rich colors and gilding, and the acanthus leaf decoration. In the adaptation of this initial, the artist decided to add extra ornamentation to the trunk of the "J" to break up the starkness of the verticals.

In the course of this project, we will be looking at flat gilding onto size, at ways of drawing and painting knotwork, and at a variety of highlighting techniques.

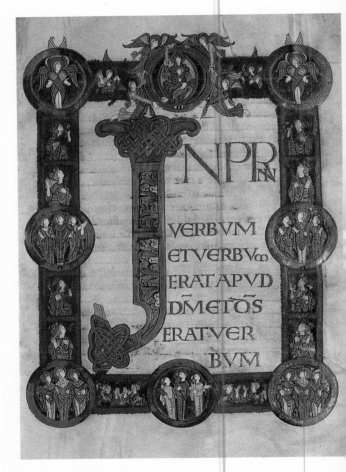

INITIAL "J" FROM THE GRIMBALD GOSPELS
early 11th century

YOU WILL NEED

- Pencil
- Ruler
- Tracing paper
- Heavy watercolor paper
- Brushes — Sable 0,00
- Gum ammoniac size
- Transfer gold
- Dog-tooth burnisher
- Glassine
- Large soft brush
- Liquid detergent

GOUACHE PAINTS
- Ultramarine blue
- Cerulean blue
- Zinc white
- Light purple
- Vandyke brown
- Winsor blue
- Spectrum yellow
- Alizarin crimson
- Lemon yellow
- Scarlet lake
- Permanent white
- Lamp black

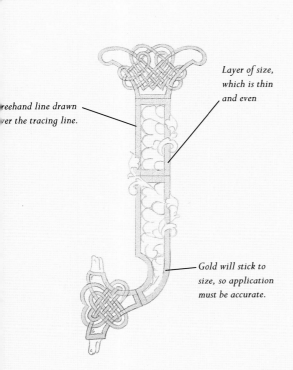

Freehand line drawn over the tracing line.

Layer of size, which is thin and even

Gold will stick to size, so application must be accurate.

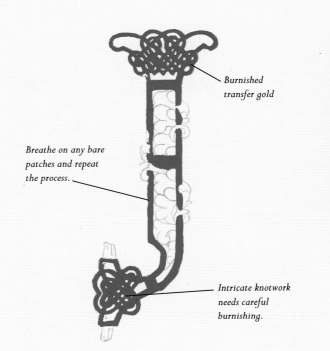

Burnished transfer gold

Breathe on any bare patches and repeat the process.

Intricate knotwork needs careful burnishing.

ROMANESQUE

T I P

Apply the sheet of transfer gold with one movement, without twisting it, and then press the gold into the size with your fingers, through the backing sheet.

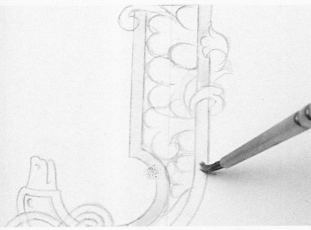

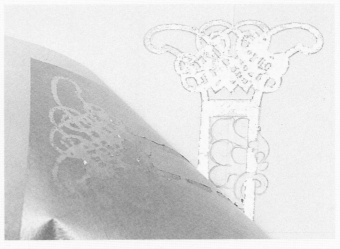

A ruler was used to construct the rough, but if possible, retrace the outline freehand once you have transferred it to your good paper. A ruled line tends to have a deadpan uniformity about it that is less attractive. For the flat gilding, use gum ammoniac size. Paint the size on carefully, keeping the layer thin and even. Scrape off any stray marks when dry. Draw some shapes to practice on first.

2 Once the size is dry, breathe on it to moisten it before applying a sheet of transfer gold (see Tip). Lift up one edge of the transfer to see if the gold has adhered well. Any bare patches can be breathed on again and the transfer process repeated. Burnish with a dog-tooth burnisher through glassine. Brush away excess gold from the edges with a soft brush.

The outlining of the knotwork is tricky. With your source in one hand, follow one line at a time, going "over" and "under" the crossing strands. It is best to paint all the lines going one way, then turn the initial around and paint those going at right angles.

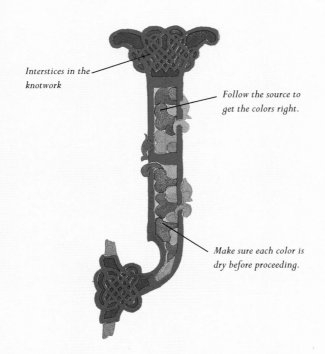

Interstices in the knotwork

Follow the source to get the colors right.

Make sure each color is dry before proceeding.

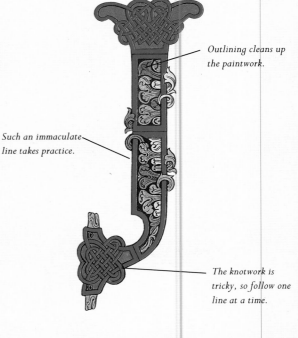

Outlining cleans up the paintwork.

Such an immaculate line takes practice.

The knotwork is tricky, so follow one line at a time.

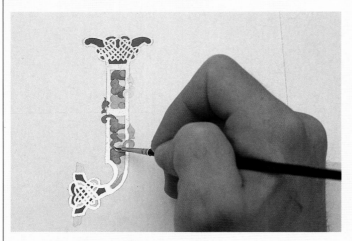

3 Fill in the areas of paint. Begin with blue (a mix of ultramarine, zinc white with cerulean, and touches of purple and brown to dull it), then green (Winsor blue, spectrum yellow, zinc white), then red (alizarin crimson, zinc white, lemon yellow, and touches of scarlet lake and Vandyke brown). Add white for pink and more yellow for the orange. You will need to concentrate on the painted knotwork interstices.

4 For the outlining, use a concentrated mix of Vandyke brown and lamp black. If the transfer gold resists the paint, add a drop of liquid detergent to the color in the palette. You will need a particularly steady hand for the main verticals, but if you follow the outlining instructions on page 21, it should not be a problem.

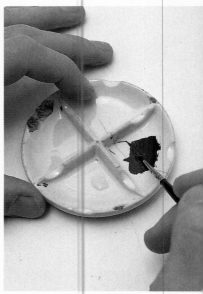

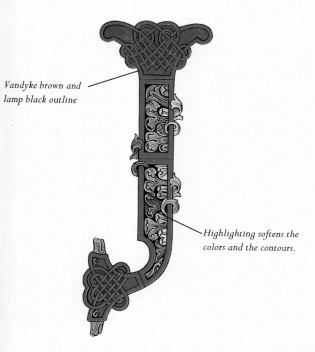

Vandyke brown and lamp black outline

Highlighting softens the colors and the contours.

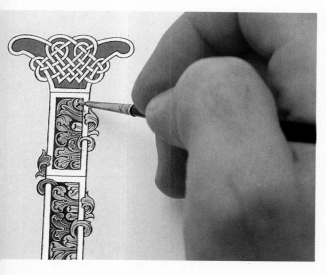

For the highlighting, mix
permanent white with a
[tou]ch of Vandyke brown. Use a
[cer]amic dish and hold it close to
[you]r work. Keep the mix quite
[dry], but wet enough to flow, and

run a very fine white line
alongside the black outline
around the acanthus leaves.

THE FINISHED LETTER

Rich in gilding and color, but with controlled
ornamentation, the result is dignified. The highlights on
the two central panels contrast well with the richer
colors around the knotwork at each end. Note the fine
details on the dog-head terminals.

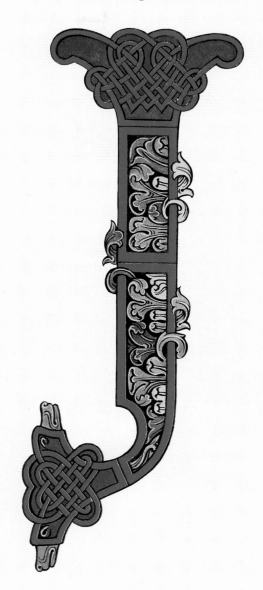

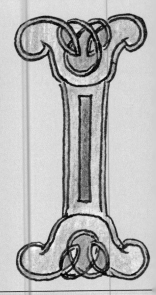

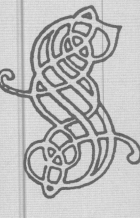

These sketchbook pages will help you to establish an idea of the variations of the Romanesque style. As you will see, there is a tendency for some overlap between styles both in period and in motifs. Hence, you will often find Celtic and Romanesque illumination being created at the same time. You will also find motifs from both styles successfully combined – Celtic knotwork used with Romanesque acanthus leaves, for example.

On these pages, you will see that Romanesque decoration appears more ordered when compared with Celtic decoration. For example, when animals are used, the Romanesque arrangement is less contorted and the letters themselves are often more upright, with straighter limbs.

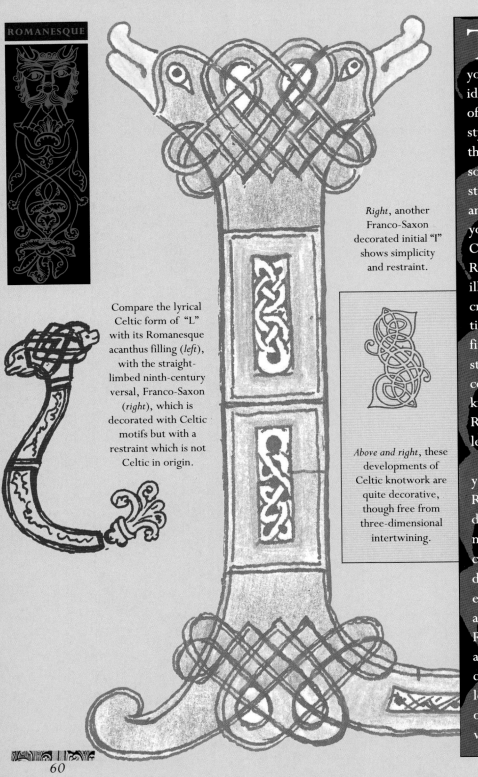

Right, another Franco-Saxon decorated initial "I" shows simplicity and restraint.

Compare the lyrical Celtic form of "L" with its Romanesque acanthus filling (*left*), with the straight-limbed ninth-century versal, Franco-Saxon (*right*), which is decorated with Celtic motifs but with a restraint which is not Celtic in origin.

Above and right, these developments of Celtic knotwork are quite decorative, though free from three-dimensional intertwining.

60

Initials of the time
were highly decorative,
such as this sketch of a
"D" (*above*).

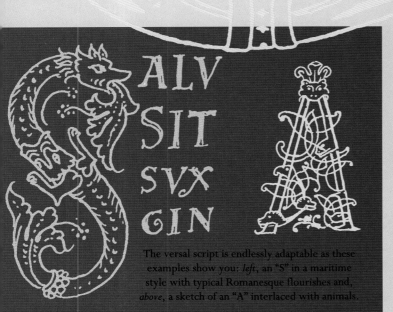

ALV
SIT
SVX
GIN

The versal script is endlessly adaptable as these
examples show you: *left*, an "S" in a maritime
style with typical Romanesque flourishes and,
above, a sketch of an "A" interlaced with animals.

Above, decorated more grandly,
an "O" based on the Canterbury
School, c.1000, and, *above left*, a
"C" filled with spiraling
branchwork and acanthus leaves.

61

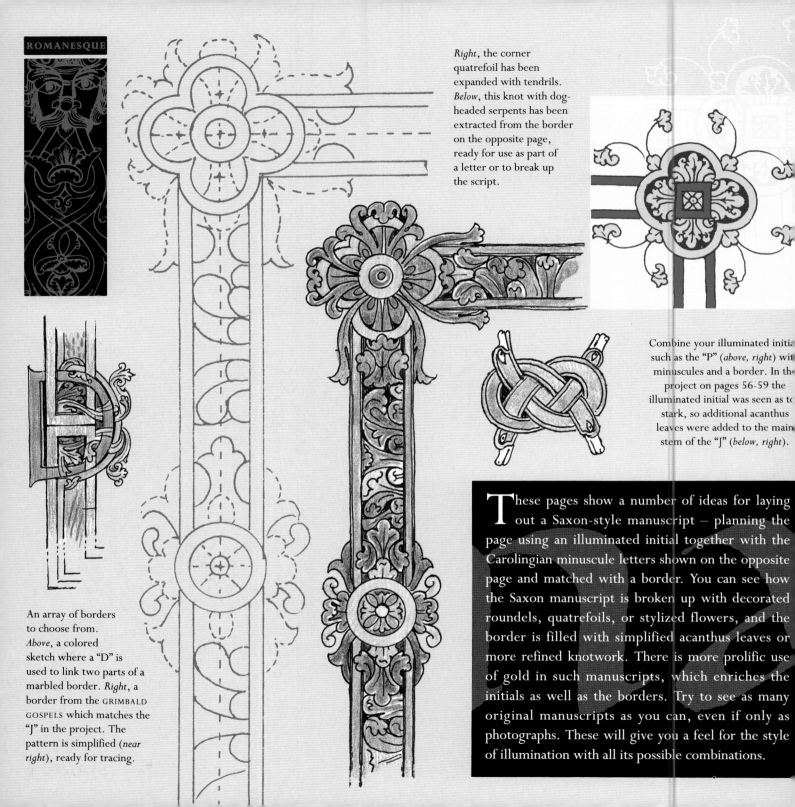

Right, the corner quatrefoil has been expanded with tendrils. *Below*, this knot with dog-headed serpents has been extracted from the border on the opposite page, ready for use as part of a letter or to break up the script.

Combine your illuminated initia such as the "P" (*above, right*) wit minuscules and a border. In the project on pages 56-59 the illuminated initial was seen as to stark, so additional acanthus leaves were added to the main stem of the "J" (*below, right*).

An array of borders to choose from. *Above*, a colored sketch where a "D" is used to link two parts of a marbled border. *Right*, a border from the GRIMBALD GOSPELS which matches the "J" in the project. The pattern is simplified (*near right*), ready for tracing.

These pages show a number of ideas for laying out a Saxon-style manuscript – planning the page using an illuminated initial together with the Carolingian minuscule letters shown on the opposite page and matched with a border. You can see how the Saxon manuscript is broken up with decorated roundels, quatrefoils, or stylized flowers, and the border is filled with simplified acanthus leaves or more refined knotwork. There is more prolific use of gold in such manuscripts, which enriches the initials as well as the borders. Try to see as many original manuscripts as you can, even if only as photographs. These will give you a feel for the style of illumination with all its possible combinations.

carolingian minuscule

P

a b c d e
f g h i j k l
m n o p q r s t
u v w x y z &
œ ß ø .⸪.
1 2 3 4 5 6 7 8 9 0 0

You can use your imagination to find ways of breaking up or joining your Romanesque borders (*above*).

You could arrange this "J" in several ways on the page: surrounded by a border with the text in gold capitals (*left*); or in two columns with borders (*right*). Use large capitals with this initial rather than minuscules, which might make it appear isolated.

EMPEROR HENRY II'S PERICOPES

This rich but simple Ottonian "V" has been taken from *Pericopes of Henry II*, which date from the early eleventh century, and are now in the Bayerisches Staatsbibliothek, Munich, Germany. Pericopes are portions of scriptures written to be read in public worship. The "V" characterizes the Ottonian style, in almost every way; the letters were very large on the decorated page, with the words of the script fitted around them.

The initial has highly burnished gold-foliated branchwork, with intense points of color in the interstices. To complement the richness of the gold, the outlining in red rather than black. This outline also serves to add relief to the main strokes of the initial by indicating the original calligraphic construction, that is, the two strokes of each line of the "V."

In this project, another type of gold size is used. This size is commercially prepared and overlaid with transfer gold. Color is then added, and the outline completes the design. To replicate the full glory of the original, you would need to surround the initial with purple.

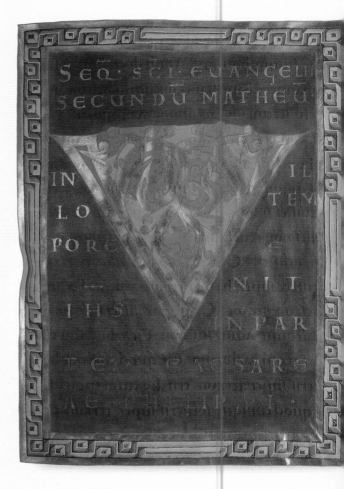

INITIAL "V" FROM THE PERICOPES OF HENRY II
early 11th century

YOU WILL NEED

- Pencil
- Tracing paper
- Watercolor paper
- Size
- Fine, old brush
- Transfer gold
- Dog-tooth burnisher
- Glassine
- Large soft brush
- Brushes — Sable 0,00

GOUACHE PAINTS
- Ultramarine blue
- Light purple
- Zinc white
- Winsor green
- Winsor blue
- Lemon yellow
- Scarlet lake

Size painted on in a thin, even layer.

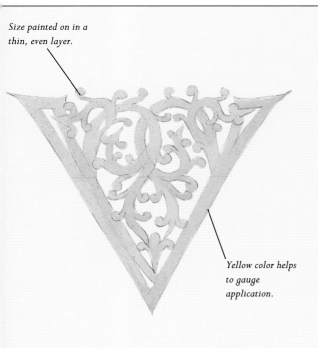

Yellow color helps to gauge application.

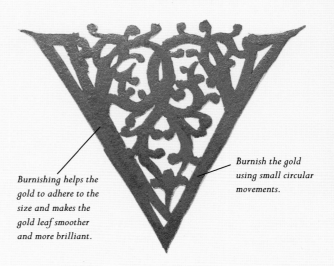

Burnishing helps the gold to adhere to the size and makes the gold leaf smoother and more brilliant.

Burnish the gold using small circular movements.

T I P

When tracing onto your good paper, do not go over the outline with too much pressure, or you will create an indented line on the paper.

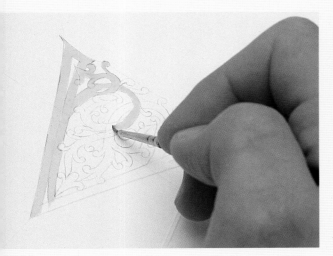

Transfer the design to a piece of good watercolor paper and prepare the size (commercial gold size) by diluting it with equal parts of water. Mix it well and apply it with a fine, old brush. Apply the size thinly to make an even surface with firm, flowing strokes. Don't work it too much. Leave it to dry for about half an hour. Wash the brush out quickly with hot water after use.

2 Having breathed on the size to moisten it and applied a sheet of transfer gold, press the gold firmly into the size. With a smooth dog-tooth burnisher, burnish the gold through glassine paper, but don't press too hard. Systematically tackle every fraction of an inch of the gold.

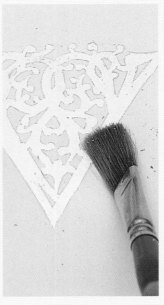

3 Brush away excess gold with a large, extra-soft brush.

The outline will cover up any problems.

Use the flexibility of the brush to work around these intricate shapes.

Keep the brush sparsely loaded with paint.

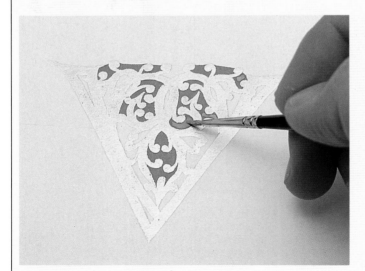

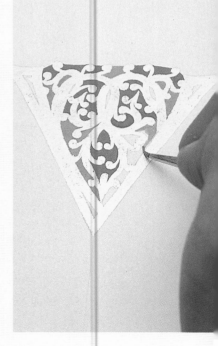

5 Continue the flat color with green (Winsor green, Winsor blue, lemon yellow, and zinc white). Don't let your hand dirty your work; rest it on a piece of paper. You can hold a tissue in your other hand to wipe the brush.

4 Using a sable 0 brush, mix purple gouache from ultramarine blue, light purple, and zinc white. It should be the consistency of thin cream. Be careful not to go over the gold as

you paint. If you do, carefully remove it with a clean brush and water. Remember, outlining can cover a multitude of such sins.

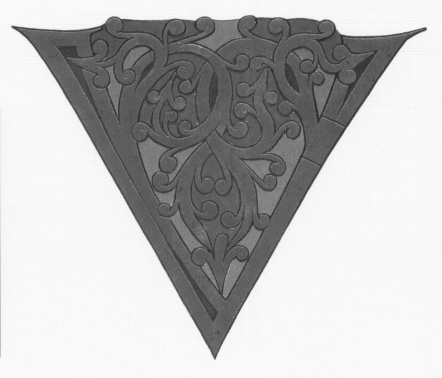

THE FINISHED LETTER

This piece is truly rich, smacking of imperial grandeur. You can imagine how it would have looked on the dyed purple vellum used by Ottonian illuminators. You can see the influence of metalwork design on such illumination, reinforced by the gilding. If you look carefully, you will see that the width of the outline varies, adding life to the illumination – this was considered to be part of the artistry of the professional.

*onsult original for
eas of red*

*The gold is
given an added
dimension.*

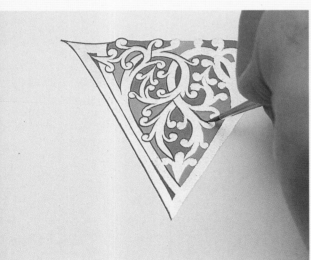

Add the final color, red
(scarlet lake and a touch of
mon yellow) to the
umination and then use it to
tline the gold. Use a size 00
ush with a good point for the

outlining. The thicker paint
adheres well to the gold, so this
is not a problem.

Above, based on the eleventh-century BOOK OF PERICOPES, interlacing at the termination of a letter sprouts nodules seen also on the stem of the "I" (*right*). Note the simple heart interlace at each end.

As the Ottonian style developed, geometric designs associated more with the Celtic and other earlier styles were abandoned for motifs with a more classical origin. Where the geometry did live on, it started to grow and sprout — at first with almost bud-like protuberances, then stylized leaves appeared which in time became more natural. The use of gold was important, giving a grander and richer appearance to the illumination and therefore keeping the letter within the status of the patrons who commissioned the work. Try using the geometric styles in your own illustrations, combining patterns with either stylized or more natural plant forms.

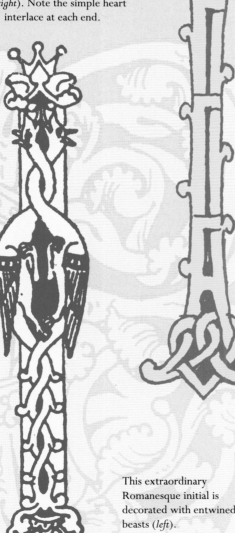

This extraordinary Romanesque initial is decorated with entwined beasts (*left*).

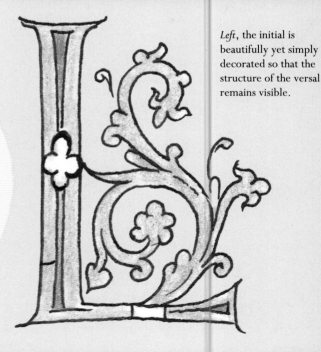

Left, the initial is beautifully yet simply decorated so that the structure of the versal remains visible.

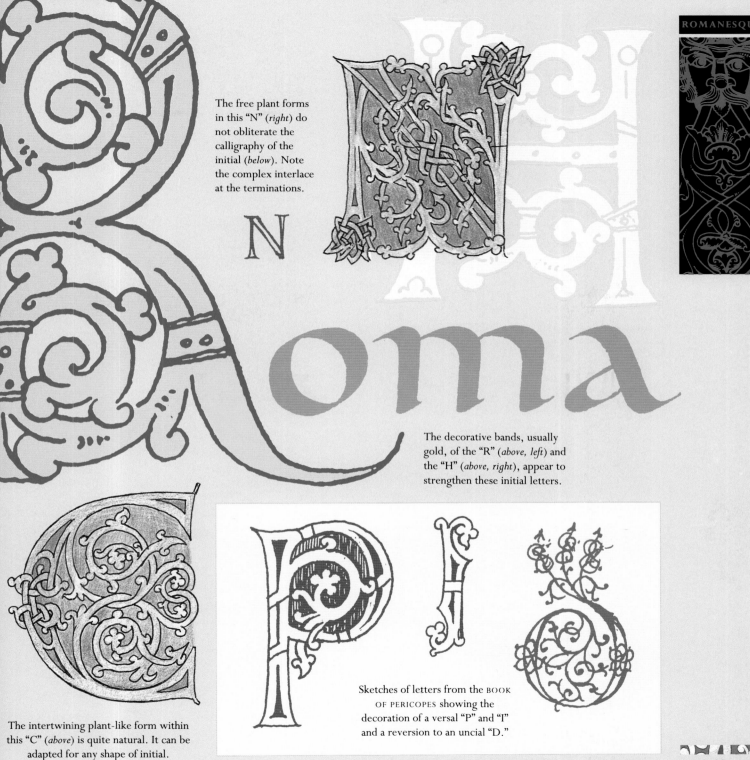

The free plant forms in this "N" (*right*) do not obliterate the calligraphy of the initial (*below*). Note the complex interlace at the terminations.

N

Roma

The decorative bands, usually gold, of the "R" (*above, left*) and the "H" (*above, right*), appear to strengthen these initial letters.

The intertwining plant-like form within this "C" (*above*) is quite natural. It can be adapted for any shape of initial.

Sketches of letters from the BOOK OF PERICOPES showing the decoration of a versal "P" and "I" and a reversion to an uncial "D."

This pattern (*right*) represents the medieval convention for clouds – nebuly.

The architectural border (*left*) incorporates part of a house in the top corner.

The Ottonian style of illumination saw a new sophistication, growing from the Carolingian Renaissance and further developing in the successive courts of the Emperors Otto. You can see the flowering of a new, more architectural form of decoration, based on classical idioms. This leads to a more three-dimensional treatment of the illumination and the borders. Some examples promoted the illusion of a classical inscription using columns, capitals, pediments, and so on to frame the script. Harking back to the grandeur of the classical emperors, too, some Ottonian illumination is worked on vellum dyed a deep purple. Experiment with your own ideas, perhaps depicting buildings of your choice in these charming achitectural style borders.

Right and below, the Ottonian key pattern is created with a grid that is 4 squares wide. The triangles are then filled and the lines connected.

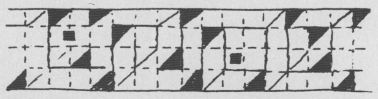

Architectural structures (*right*) can completely frame an initial.

S·MATHEVM

UMNATUS

In a trial rough for the Ottonian "V" project, background color and secondary capitals are included (*right*). The "V" from the project was traced from this one (*below*).

ROMANESQUE

Although the Ottonian style was predominantly architectural, interlace was still popular at this time, growing more complicated (*right*).

Coins, in the Roman manner, were often incorporated into the decoration (*above*). Flat gold could be used for the interlace and border edge.

Here the "V" is placed in the center and surrounded by text.

A MESSAGE TO MY
V
A L
ENT INE

An open design of capitals for Valentine's Day.

The original layout of the Ottonian "V" used as a source in the project.

THE LINCOLN PSALMS

This delightful initial shows King David, playing his harp. It comes from a Gloss on the Psalms in a psalter, now in Lincoln Cathedral, England, and was executed in the twelfth century. King David is seated on a throne, with stylized curtain on each side of him — curtains are usually wrapped around columns in medieval portrait miniatures. There is a bird apparently "talking" into the King's right ear, and a mystical griffin-like animal forms the horizontal stroke of the "D."

The asymmetrical nature of this scene is part of its appeal, together with the charming lyrical sway, which you must take care not to lose in the process of tracing and enlarging.

In this project, simple raised gilding is tackled for the first time, using glue size as a binder. Such size is freely available and a good way to start gilding, as it enables you to practice handling gold and to learn the technique of burnishing.

INITIAL "D" FROM THE GLOSS ON THE PSALMS
12th century

YOU WILL NEED

- Pencil
- Tracing paper
- Watercolor paper
- Glue size
- Brushes — Sable 0,00
- Transfer gold
- Dog-tooth burnisher
- Large soft brush
- Powder gold
- Gum arabic
- Distilled water

WATERCOLOR PAINT
- Yellow ocher

GOUACHE PAINTS
- Scarlet lake
- Alizarin crimson
- Zinc white
- Ultramarine blue
- Winsor blue
- Lemon yellow
- Vandyke brown
- Lamp black
- Permanent white

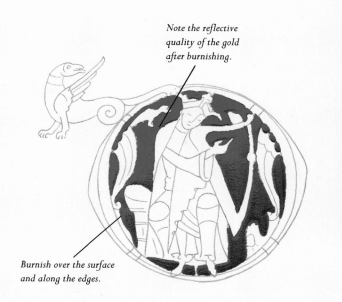

Two layers of glue size

Coloring the size yellow helps you to see it.

Note the reflective quality of the gold after burnishing.

Stylized curtain

Burnish over the surface and along the edges.

With glue size you can gradually build up the relief of the final raised gold by adding extra layers, once the previous one is dry. You will find the first layer sinks into the paper.

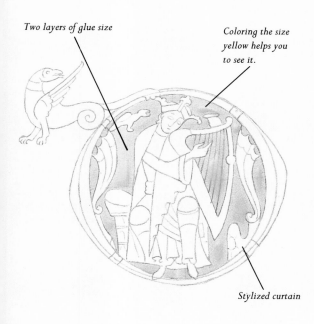

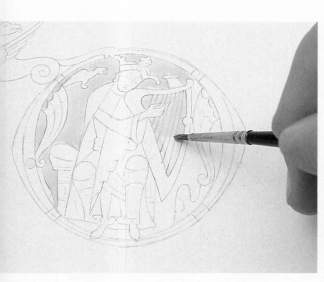

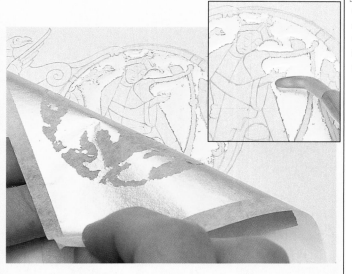

The binder used to give a raised surface in this project glue size – white glue, mixed 50 with water and a little low ocher watercolor. Paint the first layer and allow it to dry for half an hour, then add another. Paint around the edges first, then "spoon" more into the center.

2 Once the glue is dry, breathe hard on it to moisten it, then apply a sheet of transfer gold. Press the gold quite hard into the size – there is no danger of it breaking up, unlike gesso. Burnish straight onto the gold (inset). Work over the surface and along the edges to press the gold into the size and smooth it out. Brush off any excess gold.

Golden coin in
griffin's mouth

The duller powder
gold contrasts with
the gold leaf.

Use the flexibility of th
to apply the paint with
working it too much.

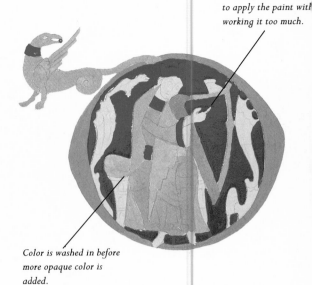

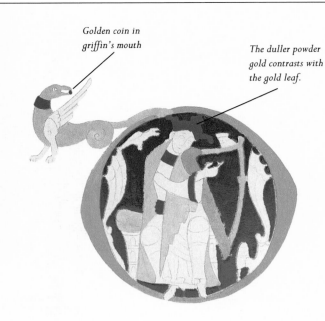

Color is washed in before
more opaque color is
added.

TIP

You will need to find the right consistency for the white highlights — too wet and it will disturb the gouache beneath, too dry and it will sit unhappily on the smooth paint.

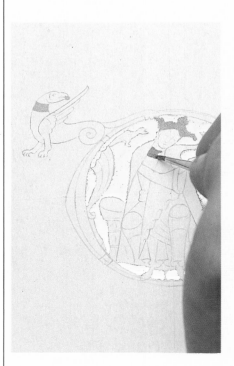

3 Fill in King David's crown, collar, belt, and cuff, with duller powdered gold. Use this, too, for the griffin's collar and the coin in its mouth. Mix powdered gold with gum arabic and distilled water (see page 24) and apply it with a small brush. Once the gold is quite dry (burnish a tiny area first to make sure), burnish well.

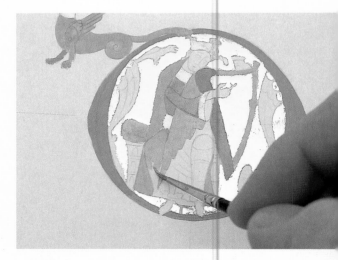

4 Apply the colors in this piece as washes, so that the pencil lines beneath are not lost. They will be needed as a guide for the outlining. Start with the salmon pink (scarlet lake, alizarin, yellow ocher and zinc white). Then add the blue (ultramarine and white) and th green (Winsor blue, lemon yellow, and white). Finally, ad the areas of white.

ck detailing will
ddded on top of
gold.

*Practice the circles
on some paper first.*

*Detailing will be added
in a stronger version of
the same mix.*

THE FINISHED LETTER

The artist has managed to retain the character and sway
of the original even though for reference he used a
postcard that had a blurred image and unreliable color
reproduction. This graceful illumination made use of
the artist's in-depth knowledge of such manuscripts. He
used the postcard to check on color distribution and
other important details, and to ensure that he had
preserved the essence of the original illumination.

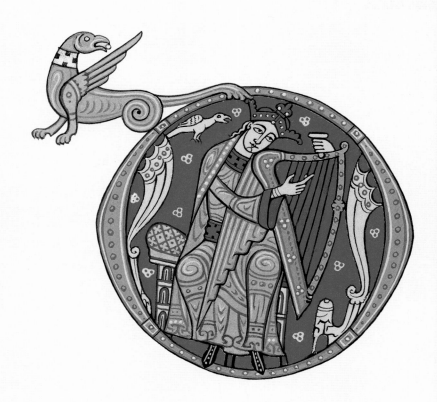

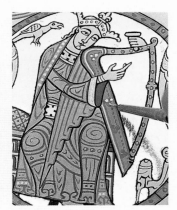

There are four stages of
detailing and outlining.
st, add details with the deep
d (scarlet lake and alizarin
mson) to the throne, harp,
eve, and initial. Next, add the
tailing on the individual
shes in a darker, stronger
rsion of the same mix.

6 Complete the outlining of
the initial in the usual mix of
Vandyke brown and lamp black.
Then use the same mix to add
details to the King's gold crown,
collar, and belt, as well as to the
collar of the griffin. Finally, add
highlights with permanent white
(see Tip).

Another development in the Romanesque period was the increased popularity of the historiated initial, where the center of the initial is decorated with a miniature painting. This device has obvious potential for adaptation, and many ideas are shown on these sketchbook pages. You could incorporate human or animal portraits or record history in a tableau.

With such a small space, your design must be carefully simplified without looking too stylized. You will need to sketch an idea and then refine it down until only the necessary elements remain. Take time at the sketching stage to get the design just right – it may take a number of sketches before you achieve the style you desire.

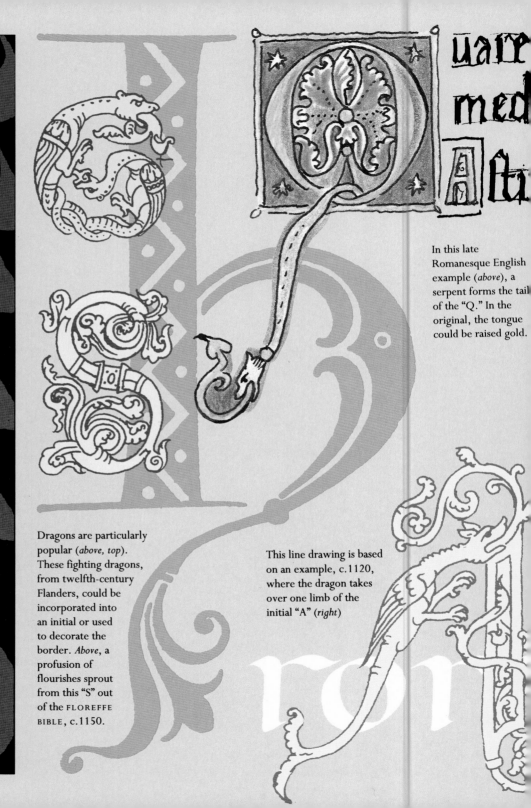

Dragons are particularly popular (*above, top*). These fighting dragons, from twelfth-century Flanders, could be incorporated into an initial or used to decorate the border. *Above*, a profusion of flourishes sprout from this "S" out of the FLOREFFE BIBLE, c.1150.

In this late Romanesque English example (*above*), a serpent forms the tail of the "Q." In the original, the tongue could be raised gold.

This line drawing is based on an example, c.1120, where the dragon takes over one limb of the initial "A" (*right*)

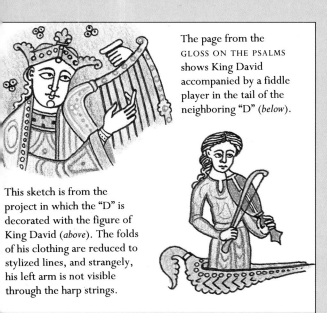

The page from the GLOSS ON THE PSALMS shows King David accompanied by a fiddle player in the tail of the neighboring "D" (below).

This sketch is from the project in which the "D" is decorated with the figure of King David (above). The folds of his clothing are reduced to stylized lines, and strangely, his left arm is not visible through the harp strings.

This angel (below) has been adapted from the WINCHESTER BIBLE, c.1150, in which it decorates a richly illuminated initial with a raised gold background.

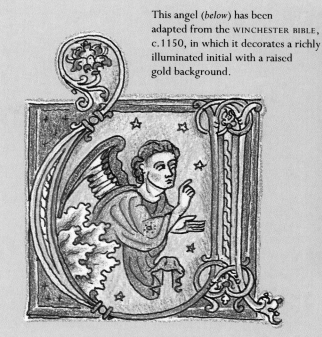

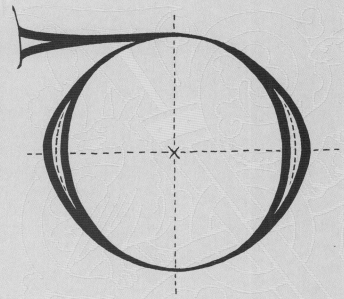

...nes

...tch of a "D" from an English ...TER, c.1160, (above) in which ...ring has been included along ...ain limbs of the initial.

Before constructing the versal "D" (above, right) with your pen, draw a circle with a pencil and compass to make sure the shape is even.

Decorative motifs such as these (*above*) can be adapted for almost any part of an illuminated manuscript. Note how animal heads are used to break up the stark edge at the top of the border.

Left, sketched from Eadwine's PSALTER, this border is decorated with scrollwork and lettering.

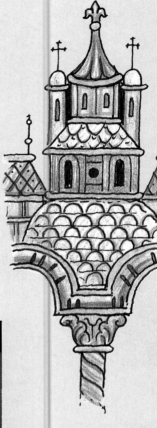

This simple building forms another architectural border (*above*). Animal heads (*below*) alternate with acanthus leaves along the edges of this border.

Illuminators were inspired by many arts and crafts which were practiced alongside their own. During the Romanesque period, the link is most easily traced between metalwork, architecture, stained glass, and illumination, but all the arts are interrelated. These artists were not only looking at the work of their contemporaries, but looking back to classical sources for inspiration. It is the same today, where we can use ideas from the masters of the past and fuse them with new themes from the present. Look for the combination of old and new themes on these sketchbook pages, and experiment with ideas of your own.

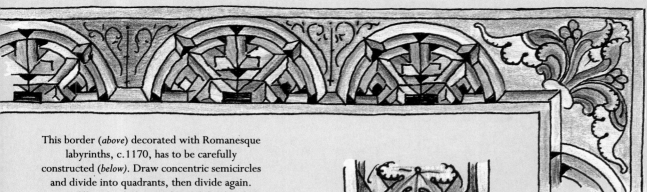

This border (*above*) decorated with Romanesque labyrinths, c.1170, has to be carefully constructed (*below*). Draw concentric semicircles and divide into quadrants, then divide again. Now, fill in the dark triangles and the details.

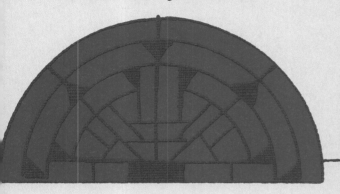

Sketched from a manuscript of the Winchester School, this border (*left*) is similar to stained glass of the same period.

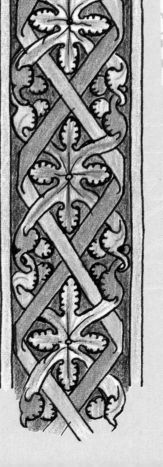

Some suggested layouts using the "D" from the project: a centered column with the letter at the head (*left*); a simple layout – perhaps with the history of the name (*below*); a Romanesque layout with border (*right*); an offset letter in the right-hand column of text (*below right*).

To look good, borders (*left and above*) need to be constructed precisely, but the line needs to be drawn freehand, or the flow will be lost. Start with simple examples which do not require too steady a hand.

romanesque

GALLERY

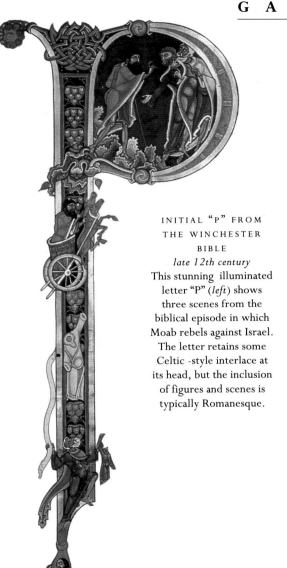

INITIAL "P" FROM
THE WINCHESTER
BIBLE
late 12th century
This stunning illuminated
letter "P" (*left*) shows
three scenes from the
biblical episode in which
Moab rebels against Israel.
The letter retains some
Celtic -style interlace at
its head, but the inclusion
of figures and scenes is
typically Romanesque.

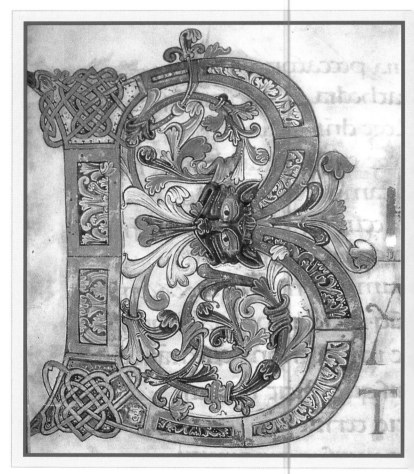

INITIAL "B" FROM THE RAMSEY PSALTER
late 10th century
This is a masterpiece of Anglo-Saxon illumination and lettering (*above*). The "B" is
lavishly gilded, incorporating interlocking terminations and infilling of acanthus
leaves. The grotesque gargoyle-like mask sprouts spirals of colorful foliage which
relate to Anglo-Saxon carving and metalwork. The manuscript is believed to have
been made at Winchester for use at Ramsey Abbey in Huntingtonshire.

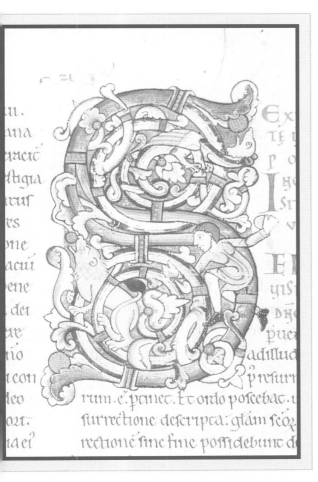

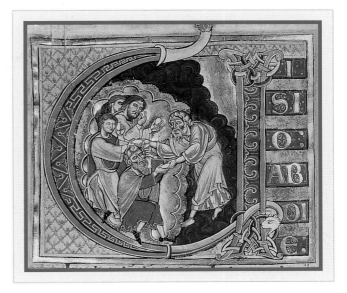

INITIAL "V" FROM THE BOOK OF OBADIAH,
WINCHESTER BIBLE
late 12th century
The historiated decoration within this initial "V" (*above*) shows
Obadiah hiding "a hundred prophets" in caves.

INITIAL "S" FROM BERENGARDUS' COMMENTARY ON
THE "BOOK OF REVELATION"
early 12th century
The whole structure of this flamboyant illuminated "S" (*above*)
merges with the intertwining and spiraling stems. A dragon climbs
among these stems, and a lion, eagerly pursued by a man,
feasts on fruit.

INITIAL "O" FROM THE SONG OF SOLOMON,
WINCHESTER BIBLE
late 12th century
This striking initial "O" (*above*) shows the King entertaining the
Queen of Sheba, enthroned together a richly domed palace.

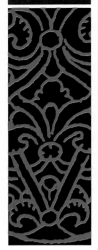

gothic

THE CENTERS of early Gothic illumination were in France, particularly Paris, and England, where, in the course of the thirteenth century, secular illuminators took over from their monastic colleagues. With a new emphasis on books for the people, both books and illumination became smaller in scale than in the Romanesque period.

In the course of the Gothic period, an interest in realism grew, culminating in the flower-strewn borders produced by the Flemish masters at the end of the fifteenth century. Spiralling plant tendrils often decorated initial letters, with Byzantine blossoms inset in the centers. Highlighting became popular, as did the use of reversed curves, known as nebuly after the heraldic term for clouds.

Italian painting had an increasing influence on the Gothic illuminators, seen early on in the work of Jean Pucelle, who worked in Paris in the early fourteenth century, and later, in the superb work of the Limbourg brothers. The Limbourg brothers worked in Paris for the Duc de Berry between 1413 and 1416, creating two of their greatest masterpieces, *Les Belles Heures* and *Les Très Riches Heures*. It was the popularity of such books which spawned mass production of illuminated works, sadly often resulting in repetitive and unimaginative pieces.

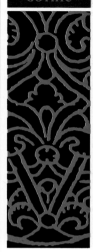

LOMBARDIC

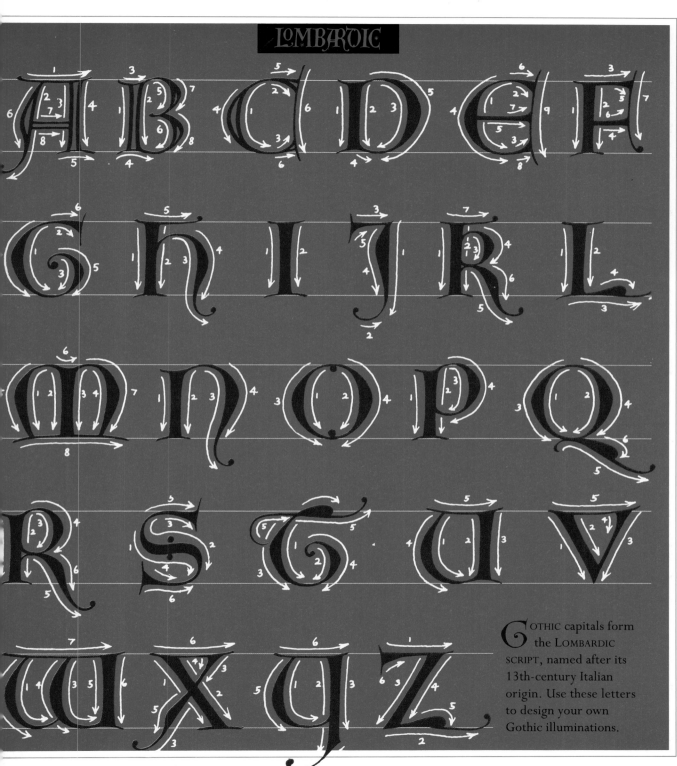

The Lombardic Script is more decorative than practical, and there are often alternative forms based on Roman or Celtic shapes.

The script may be formed with a brush or written with a pen held horizontally. Compared with Versals, there is a greater contrast between the thick and thin strokes of this script, and the spaces between the parallel strokes may be filled or left unfilled. The letters may be compressed in weight, height, or width and manipulated by reducing them or by amalgamating neighboring stems.

Gothic capitals form the Lombardic script, named after its 13th-century Italian origin. Use these letters to design your own Gothic illuminations.

THE BESTIARY LETTER

This complex letter design, on a page depicting a lion, comes from a bestiary, c.1240, now held in the British Library. Also included in the bestiary are pages which depict hedgehogs, cats, and hyenas. Among the fantasy animals included are the griffin and the caladrius, which divines the fate of a sick person by facing him or turning away.

The design was traced and then reconstructed on some layout paper using a compass and a ruler. This "rough" was traced and transferred to vellum, which is used here for the first time. The design was then penciled in freehand to retain a lively line and avoid uniformity. An interesting and unusual aspect of this design is the shadowing along one side of all the colors. This was executed in a half-wash and adds an impressive three-dimensional effect.

This project tackles the more advanced raised gilding technique, using glue size as a binder.

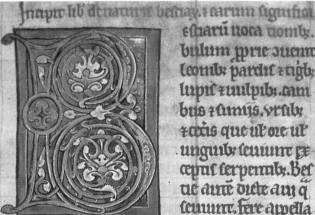

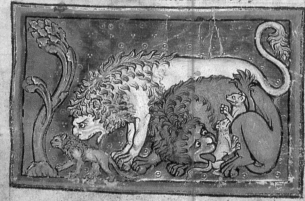

INITIAL "B" FROM THE BESTIARY OF GUILLAUME LE CLERC
early 13th century

YOU WILL NEED

- Pencil & tracing paper
- Compass
- Ruler
- Vellum
- Mapping pen & fine point
- Waterproof ink
- Fine, old brush
- Glue size
- Transfer gold
- Dog-tooth burnisher
- Large soft brush
- Brushes — Sable 0,00

GOUACHE PAINTS

- Ultramarine blue
- Light purple
- Winsor blue
- Lemon yellow
- Alizarin crimson
- Scarlet lake
- Yellow ocher
- Vandyke brown
- Zinc white
- Permanent white
- Lamp black

An intricate design, so take care with tracing

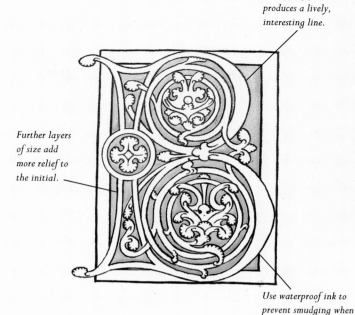

Use a compass for the circles.

A mapping pen produces a lively, interesting line.

Further layers of size add more relief to the initial.

Use waterproof ink to prevent smudging when paint is added.

Using a mapping pen with a fine pointed nib, ink in the outline of the decoration on to the vellum with waterproof ink. This ink easily clogs nibs, so wipe off the nib after dipping and keep the pen moving briskly. If you prefer, you could use a designer's pen (a rapidograph).

② Add the PVA size, referring constantly to the original for guidance. Use an old brush, but one that can cope with the intricate design. Try hard to stay with the inked outline. After half an hour's drying time, add another layer of size, as you will find that the first layer sinks into the vellum.

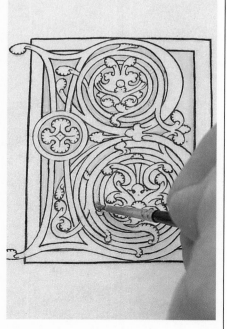

It may take a few attempts to transfer the gold

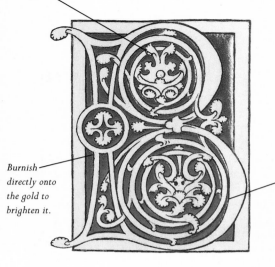

Burnish directly onto the gold to brighten it.

Note that the black outline is still visible.

Flat gouache, the consistency of cream

Sweep the pa along using flexibility of brush. Work little as poss

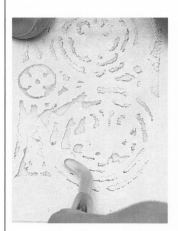

3 Blow hard on the size to moisten it and add the gold transfer quickly. Press down and check for adhesion. It may take a number of attempts to get full adhesion – working the gold with a burnisher through the transfer paper may help.

4 Once you are satisfied with the adhesion, brighten the gold using a burnisher directly on the gold surface. Remove excess gold with a soft brush.

5 Add the flat color. The vellum may resist the paint slightly, so start with a wash and then flood in the thicker color. First, paint on the dark pink (scarlet lake, alizarin, yellow ocher, and zinc white), then the blue (ultramarine and white), the green (Winsor blue, lemo yellow, and white), pale pink (lighter version of dark) and, finally, the pale yellow (yellow ocher and white).

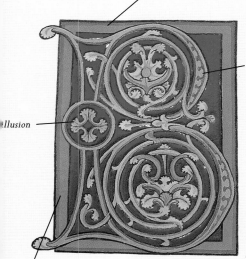

A touch of soap or egg yolk may help the paint to stick to the gilded areas.

Nebuly motif

...llusion

Practice creating dots on scrap paper.

...paque color will ...over any mistakes.

Add shadowing to all the colors, using a half wash of a ...ker mix. Make sure the paint ...in but not watery, or the ...t beneath will come away.

7 Having cleaned up the original ink line using Vandyke brown and lamp black and a fine 00 brush, reinforce the three-dimensional quality by applying dots of permanent white along the nebuly and the vegetation. Add a white line on the opposite to side the shadow line.

THE FINISHED LETTER

The brilliant gilded spirals, together with the three-dimensional colored filigree, create an initial which is complemented by the creamy color of the vellum. It is not surprising that bestiaries were so popular in medieval times: the combination of such attractive illumination and the depiction of real and fabulous animals would appeal to all. Such a work of art could be framed and should survive for many years.

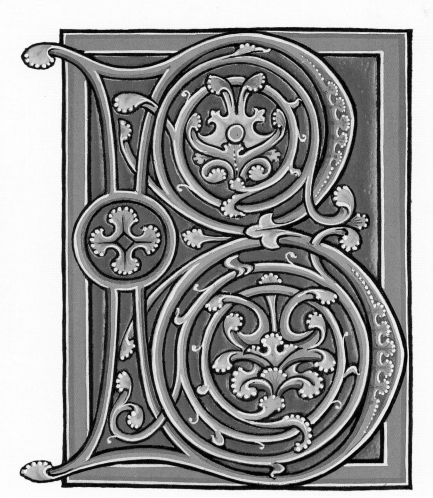

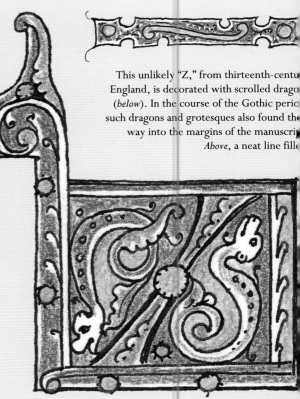

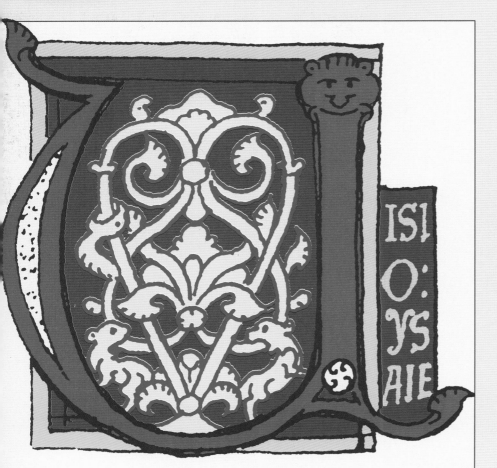

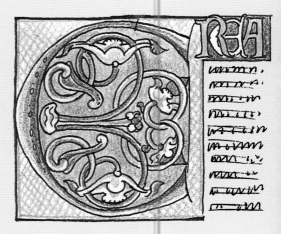

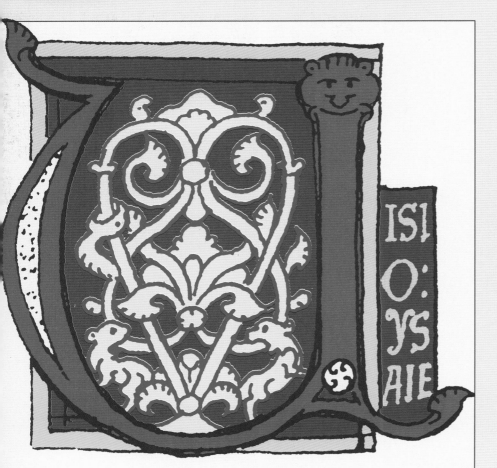

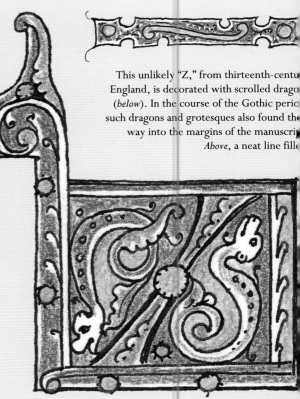

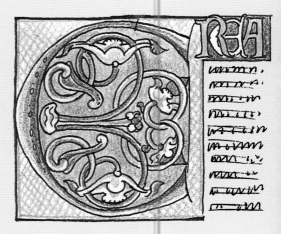

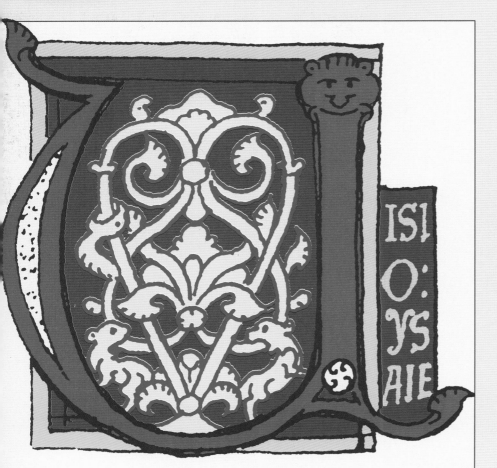

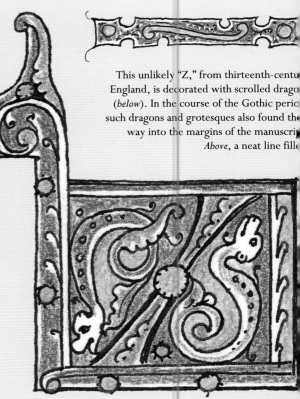

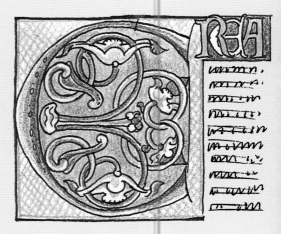

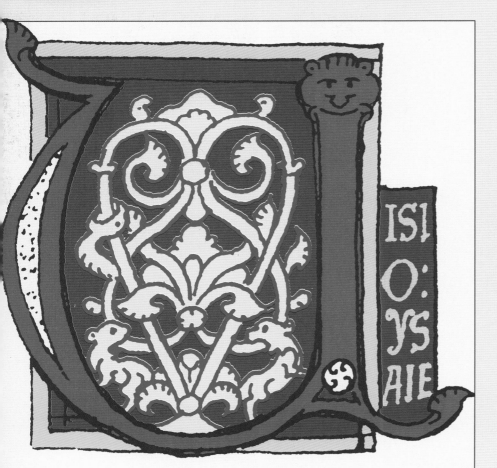

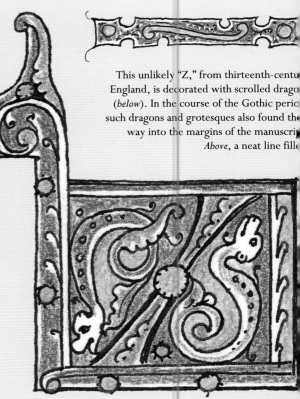

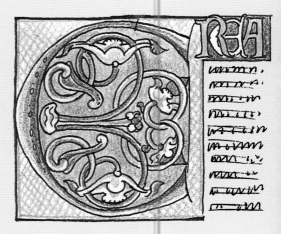

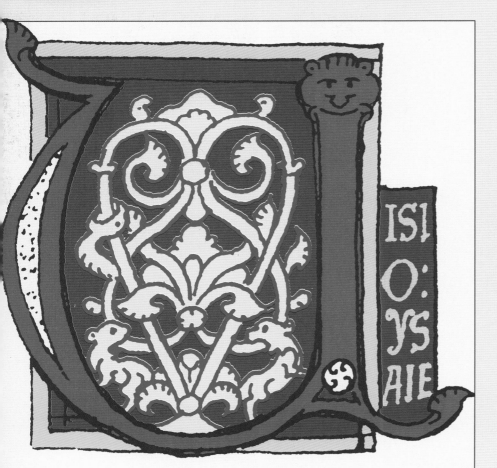

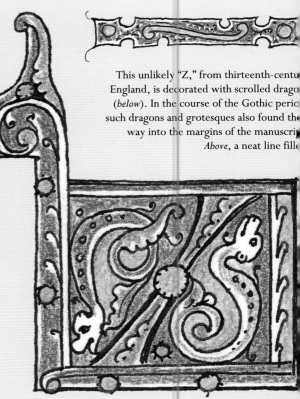

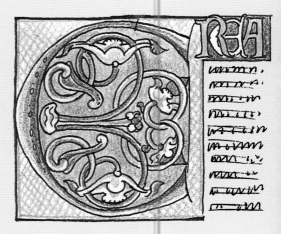

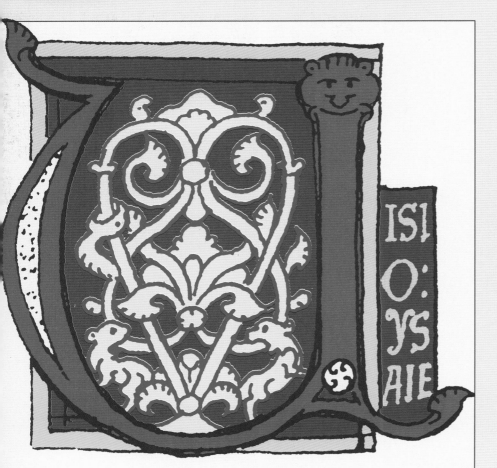

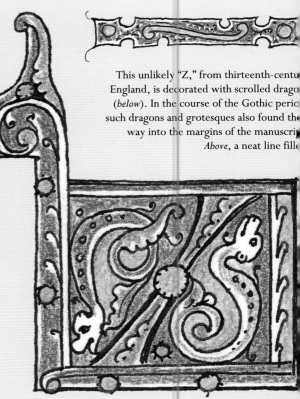

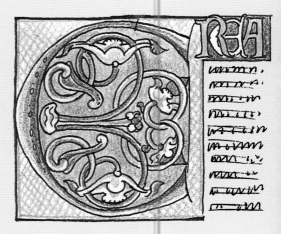

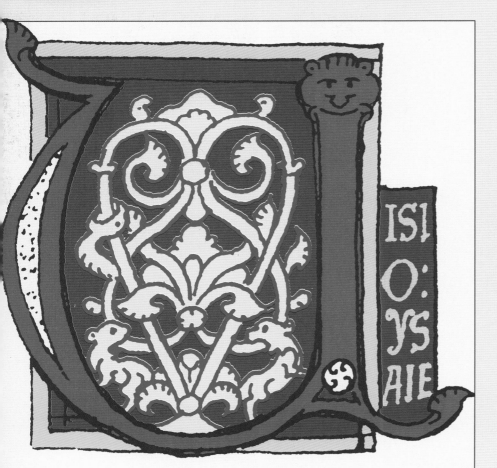

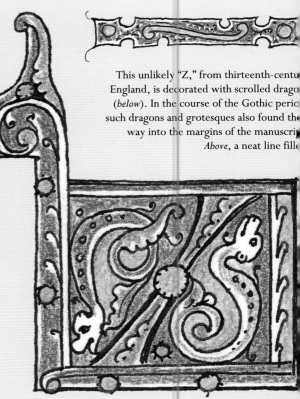

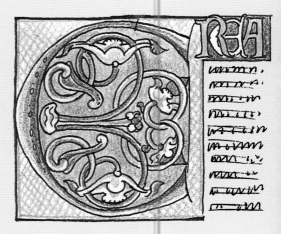

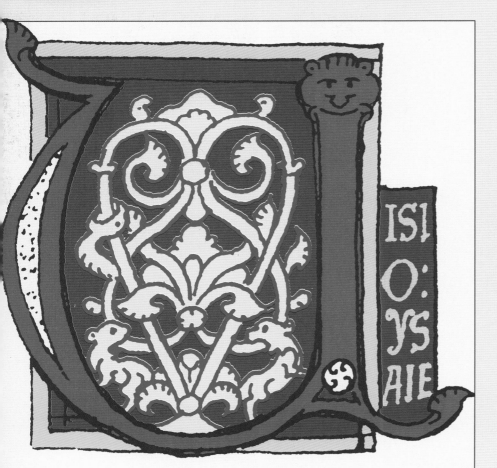

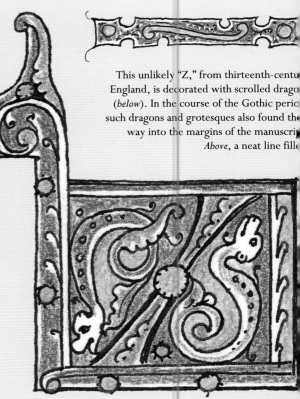

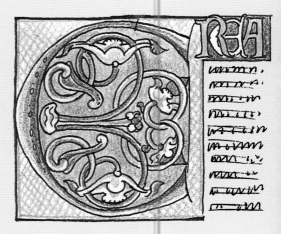

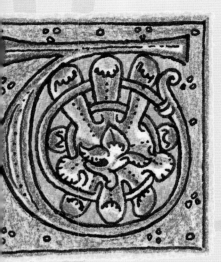

An interesting decoration of a "T" with woven petals (*left*).

The "R" (*above, left*) is restrained compared with many examples, but it provides the basis for more invention. An easily identifiable "M" from the Lombardic alphabet (*above, right*) is simply decorated.

GOTHIC

[T]he initial "B" (*right*), created [w]ith a calligraphy pen and black [in]k, formed the basis of the "B" [fr]om the BESTIARY in the Early [G]othic project. Note the strong [c]ontrast between thick and thin [l]etter parts. *Below*, a sample of [G]othic Blackletter script.

Above, another script that was popular during the Gothic period, called Lombardic script, works well with additional decorative scrolls and whimsical extensions.

anno dom

This thirteenth-century English border (*right*) from the RUTLAND PSALTER, is constructed from double curving paths crossing at regular intervals (*below*).

Decorative features: a French Gothic canopy and rose window (*above*); an angel with a censer breaking out of the border (*below, far right*).

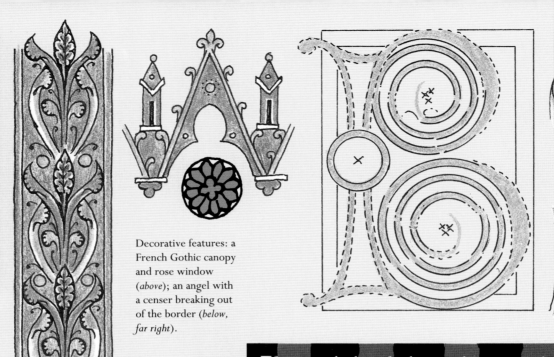

For this "B" fro[m] the proje[ct] (*right*), most the spirals can [be] constructed connecti[ng] compass curv[es] drawn with t[he] point on the cr[oss] (*left*). The dott[ed] lines may [be] drawn freehan[d]. *Left and abov[e]* details from t[he] BESTIARY "[B]

Below, a small pattern with a diapered background. *Far below*, a border with two confronting beasts at the corner, whose tails scroll magnificently along the frame.

If you are looking for historical accuracy when reproducing your Gothic manuscript, remember that Gothic books were generally smaller than the Romanesque books, catering for the new student market and for the increase in monastic orders. The layout of the page, however, should still include an illuminated initial, the accompanying script, and a decorative border. The more graceful Lombardic capitals (see page 83 for the full alphabet) combine well with the almost aggressive-looking Blackletter minuscules shown opposite. Try this combination of upper and lower case alphabets to create your own Gothic illuminations.

gothic blackletter

a b c d e f

g h i j k l

m n o p q r s t u v

A dragon acts as a line filler (*right*).

w x y z

x ß ø ∴ ⚘

BEATRIX

BEATUS

B

1 2 3 4 5

Gothic Blackletter numerals (*left*).

Lombardic capitals combine well with Gothic Blackletter minuscules. You could try working them into these layouts (*above and left*).

6 7 8 9 0 0

THE DUC DE BERRY'S PSALTER

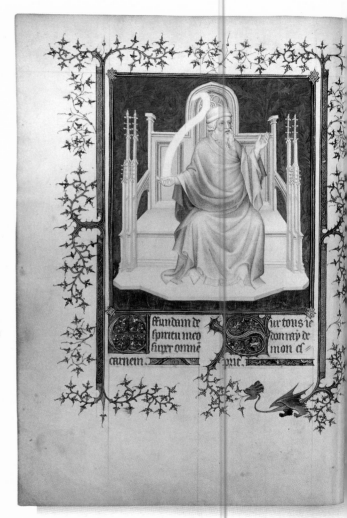

Between 1000 and 1400, the liturgical Psalter, more than any other type of book, was the bread and butter of the illuminator. In general, the Psalter started with a calendar (which was the precedent for the book of hours), followed by eight sections of psalms, and ended with hymns and prayers. There was plenty of scope for the illuminator, with illustrations for the calendar, miniatures of Old and New Testament scenes, and after the twelfth century, historiated initials for the eight sections of psalms.

This High Gothic initial "S" has been adapted from a Psalter made for the Duc de Berry in about 1380. The trailing ivy motif is more naturalistic than decoration used in earlier Gothic works and shows the influence of the Italian Renaissance on the High Gothic style.

In this project, gesso is used for the first time as a binder for layers of transfer gold and loose gold leaf (see page 25, for more detail on the gilding process). There is another first in the use of egg tempera.

INITIAL "S" FROM THE PSALTER OF JEAN DUC DE BERRY
late 13th century

YOU WILL NEED

- Pencil
- Tracing paper
- Vellum
- Mapping pen
- Waterproof black ink
- Gesso
- Fine, old brush
- Craft knife
- Dog-tooth burnisher
- Transfer gold
- Glassine
- Double thickness loose gold
- Large soft brush
- Pencil burnisher
- Egg
- Brushes – Sable 0,000,00

GROUND PIGMENTS
- Cadmium red
- Ultramarine blue
- Permanent white

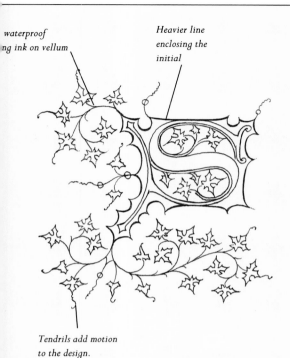

waterproof
ng ink on vellum

Heavier line
enclosing the
initial

Tendrils add motion
to the design.

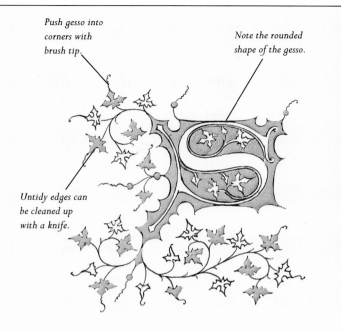

Push gesso into
corners with
brush tip.

Note the rounded
shape of the gesso.

Untidy edges can
be cleaned up
with a knife.

T I P

Use an old brush to
transfer a dab of
gesso onto the
vellum, then push
out the edges with
the brush-tip into
the shape that you
require.

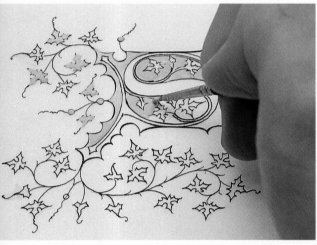

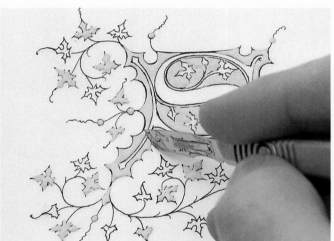

Following light pencil
tracing lines, outline the
itial with a mapping pen and
ack waterproof drawing ink on
llum. Apply the gesso with an
d brush, spooning it on rather
an painting it. Add more while
it is still wet to build up the
shape. Add extra gesso wet-in-
wet along the backbone of the
shape with delicate jabs of the
brush.

2 It is best to leave the gesso
to dry overnight. Then any
untidy edges or uneven shapes
can be carefully scraped away
with a sharp craft knife. Then use
a dog-tooth burnisher straight
onto the gesso to polish it
slightly. This means that
moisture from your breath can
condense more easily on its
surface for the next stage.

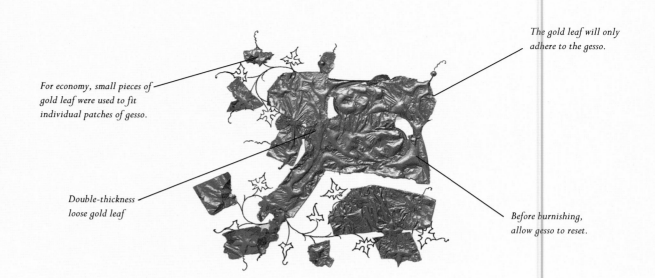

The gold leaf will only
adhere to the gesso.

For economy, small pieces of
gold leaf were used to fit
individual patches of gesso.

Double-thickness
loose gold leaf

Before burnishing,
allow gesso to reset.

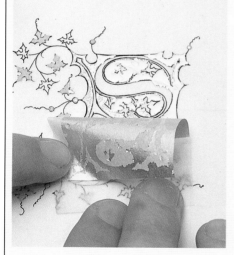

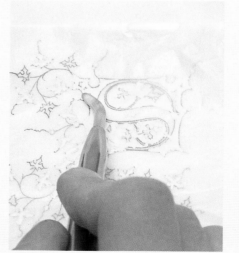

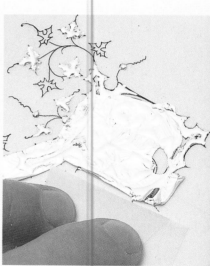

3 Add a layer of transfer gold, breathing
hard on the gesso and pressing on the
transfer gold. Work gently at first to make
sure the gesso has set firm.

4 Leave the transfer gold to set for about
half an hour before burnishing through
glassine paper. Pay particular attention to
the edges to help the gold stick.

5 Now add the double-thickness loose gold
leaf (see Tip for how to cut a piece of
gold leaf). Breathe hard on the gesso and
carefully transfer the gold to the gesso,
pressing gently through the backing paper.

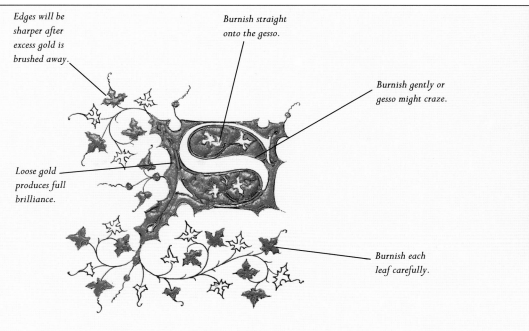

Edges will be sharper after excess gold is brushed away.

Burnish straight onto the gesso.

Burnish gently or gesso might craze.

Loose gold produces full brilliance.

Burnish each leaf carefully.

Cut out small pieces of loose gold to fit individual patches of gesso. This is more economical, and smaller pieces are easier to handle.

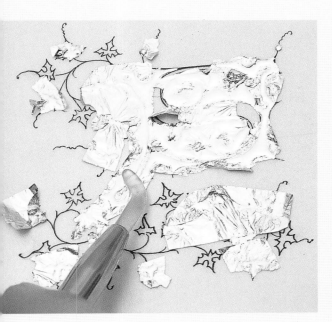

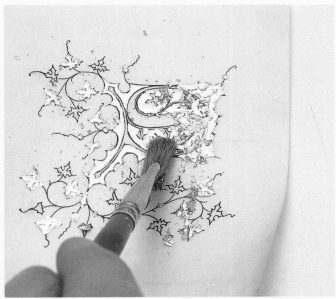

Allow the gesso to reset and then burnish directly on to e gold. Work the surface very gently. When the gold is well-adhered, brush off any excess with a soft brush.

7 Continue burnishing until full brilliance has been achieved. You might want to add another layer of gold and then re-burnish.

*Ground pigments are
not very consistent —
the white used for
the highlighting
needed further
grinding in a pestle
and mortar before it
would combine with
the egg yolk.*

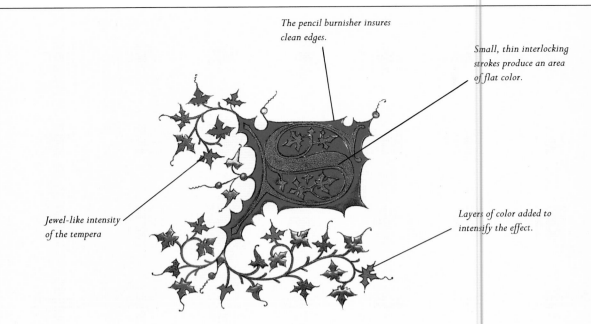

*The pencil burnisher insures
clean edges.*

*Small, thin interlocking
strokes produce an area
of flat color.*

*Jewel-like intensity
of the tempera*

*Layers of color added to
intensify the effect.*

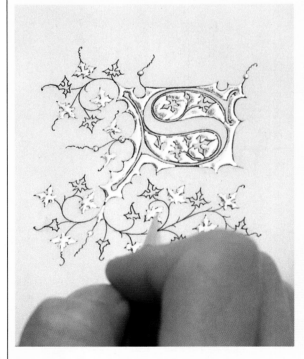

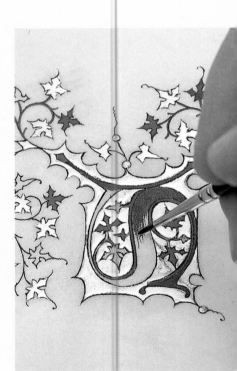

8 Draw firmly around the edges of the gesso with a pencil burnisher. This will help stick down any loose edges. Don't go over the gesso or you will leave an indented line. Brush excess gold away again, teasing it out of nooks and crannies.

9 Make up the red tempera, using cadmium red ground pigment. (See page 22 for instructions on mixing tempera.) Apply the paint in small, thin interlocking strokes. Now make up and apply the ultramarine blue. Add the color alongside the ink line of the tendrils.

THE FINISHED LETTER

The combination of the brilliant raised gilding and the jewel-like colors create a stunning piece of illumination. The shaped gesso allows the light to fall on the gold along one side, producing contrasts of brilliance. If applied correctly, it is very difficult to remove or break as the many examples surviving from medieval times testify.

Don't worry if it doesn't all work the first time. It takes practice to successfully combine all the elements needed for a perfect end result.

O For the highlighting, use your finest brush int, touched into the white e Tip). Dilute the white only a le, applying it with tiny hair-e strokes which join each er. If you overpaint the red or e, just cover with the propriate color when dry. You scrape off any stray paint, as tempera lies on the surface of vellum.

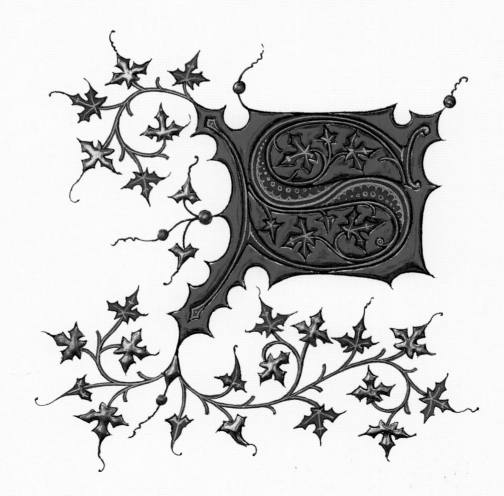

Right and below, sketches of letters from the BEDFORD HOURS show the elegance of the style with ever-increasing flourishes.

Patterns of trellising and diapering were popular as alternative backgrounds to plain gold (*right*).

Right, the wonderfully sinuous Lombardic "S" illuminated in the project is first drawn with a pen and ink.

Stylized flowers (*right*) or a dragon (*below*) can be used to "punctuate" the text, filling lines or balancing illumination elsewhere on the page.

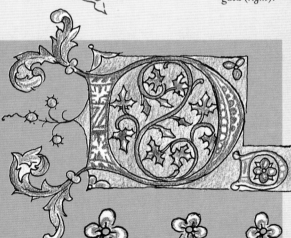

These makers of mu (*right*) play th instruments w feeling, showing a n interest in realis

Towards the end of the fourteenth century, the Gothic style metamorphosized further into a new style known as High or International Gothic, which affected arts and crafts throughout western Europe. In illumination, this style is seen at its most brilliant in the works painted by the Limbourg brothers for the Duc de Berry. The style is characterized by a general prettiness and grace, in both the decoration and the elegance and aloofness of any figure painting. There was also a new interest in the depiction of the everyday lives of working people as was so well observed in *Les Très Riches Heures*, also painted by the Limbourg brothers for the Duc de Berry.

These simple sketches are useful for recording ideas of decoration. *Top left*, a "T" entwined with ivy leaves with nebuly highlighting.

Left, trelliswork inlaid with flowers. *Top right*, heart interlacing reappears as effective embellishment. *Above*, a simple rounded "M" with trefoils.

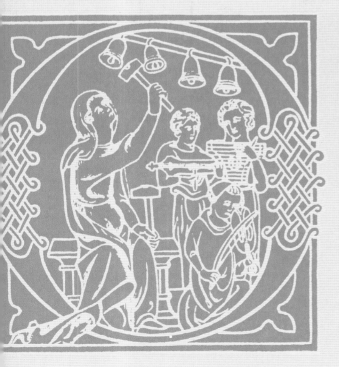

lorra Et in homi

This "G" (*left*), by the Bedford Master, is well balanced. The spiral of ivy leaves breaks up the background of raised gold into manageable areas.

Simple decorative ideas for letters: *left*, naturalistic acanthus leaf treatment; *right*, the stem of the letter is interlaced together.

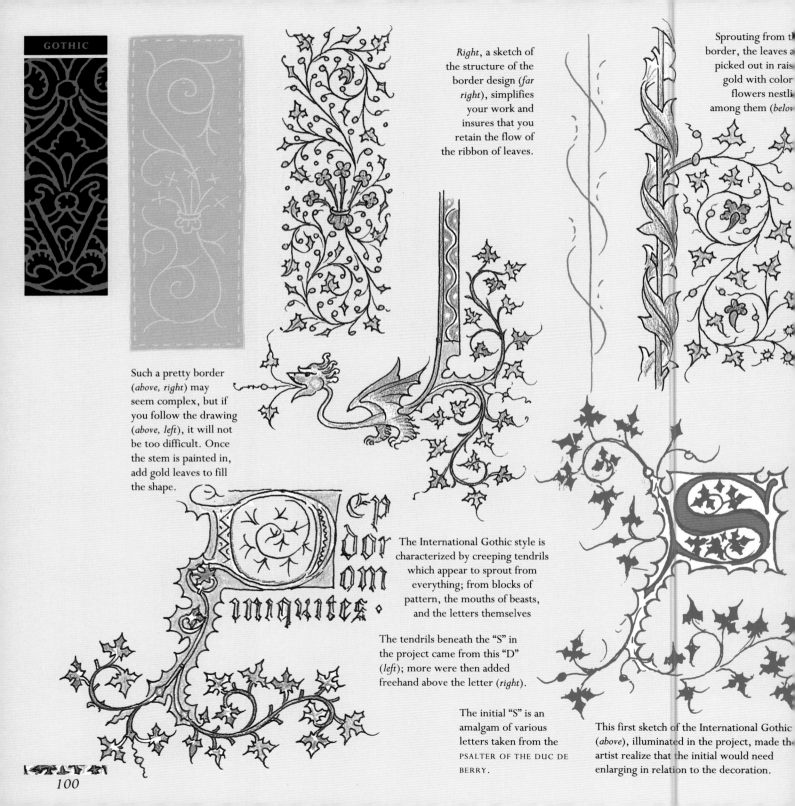

Right, a sketch of the structure of the border design (*far right*), simplifies your work and insures that you retain the flow of the ribbon of leaves.

Sprouting from the border, the leaves are picked out in raised gold with color flowers nestling among them (*below*)

Such a pretty border (*above, right*) may seem complex, but if you follow the drawing (*above, left*), it will not be too difficult. Once the stem is painted in, add gold leaves to fill the shape.

The International Gothic style is characterized by creeping tendrils which appear to sprout from everything; from blocks of pattern, the mouths of beasts, and the letters themselves

The tendrils beneath the "S" in the project came from this "D" (*left*); more were then added freehand above the letter (*right*).

The initial "S" is an amalgam of various letters taken from the PSALTER OF THE DUC DE BERRY.

This first sketch of the International Gothic (*above*), illuminated in the project, made the artist realize that the initial would need enlarging in relation to the decoration.

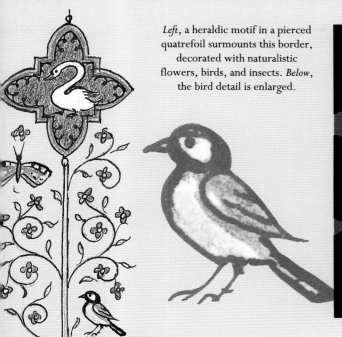

Left, a heraldic motif in a pierced quatrefoil surmounts this border, decorated with naturalistic flowers, birds, and insects. *Below*, the bird detail is enlarged.

In the course of the thirteenth century, plant forms – particularly ivy, the symbol of everlasting life – became more naturalistic, resulting in more realistic leaf work which was sometimes populated by well-observed birds, animals, and insects. You can see, from the examples on these sketchbook pages, the innate prettiness of the High or International Gothic style. This is a style which is easy to adapt and develop yourself, allowing the creeping ivy to grow from the elegant Lombardic finials. Take care when you trace such letters to retain the purity of the line, using the traced line simply as a guide and allowing your eye to recreate the scrolls and tendrils as natural forms.

A typical Gothic layout with full border and miniature illumination (*left*). Horizontal layout (*below left*) with a small border: the "S" projects out into the left-hand margin.

The interior of the project initial was taken from this "S," also from the PSALTER OF THE DUC DE BERRY.

Above, try this circular arrangement with the ivy leaves spread evenly around the "S," encircled by text.

THE BOOK OF HOURS

This original initial "D" is from a fifteenth-century French book of hours and depicts the story of David and Bathsheba. Books of hours were popular devotional books of the later middle ages and contained a series of services to be recited during the day. The letter is attractively decorated with naturalistic flowers, but it shows the results of mass production – a wooden outline, extreme simplification, hurried coloring.

The artist adapted the design of the decoration in order to isolate the initial from the miniature, the border and the text. He successfully recaptures the beauty of this age of realism, restoring the precision of the illumination, particularly in the highlighting. Translucent watercolor was used for the flowers, building them up in thin washes from light to dark. The use of gold for the background is typical of the time and, with the shadows across it, the illusion is complete.

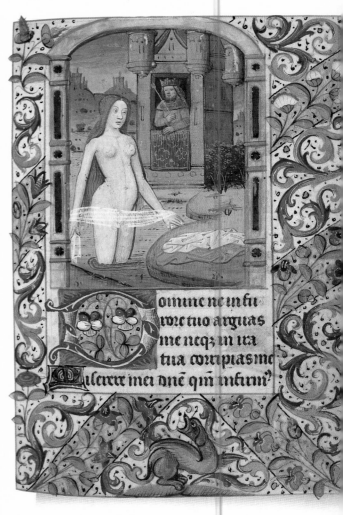

INITIAL "D" FROM A FRENCH BOOK OF HOURS
late 14th century

YOU WILL NEED

- Pencil
- Tracing paper
- Good-quality watercolor paper
- Shell gold
- Brushes – Sable 0,00,000
- Dog-tooth burnisher

WATERCOLOR PAINTS
- Winsor green
- Cobalt blue
- Cadmium yellow
- Purple lake
- Vandyke brown

GOUACHE PAINTS
- Scarlet lake
- Yellow ocher
- Zinc white
- Ultramarine blue
- Winsor blue
- Permanent white
- Vandyke brown
- Lamp black

Burnishing makes shell gold smooother and more brilliant.

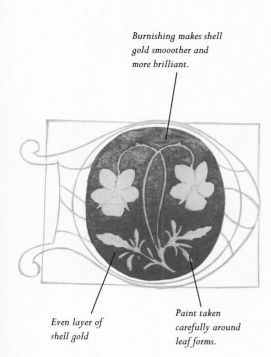

Even layer of shell gold

Paint taken carefully around leaf forms.

Bronzing

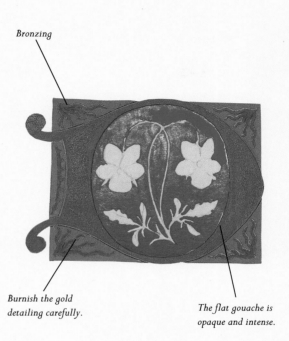

Burnish the gold detailing carefully.

The flat gouache is opaque and intense.

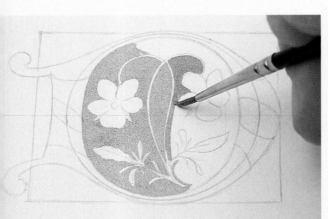

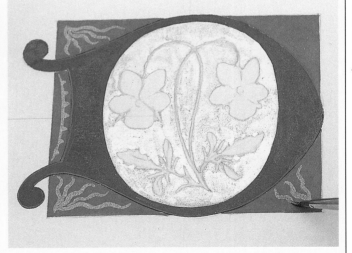

Trace and transfer the design onto some watercolor paper. The background to the flowers is painted on using shell gold – powdered gold commercially sold in small quantities (see page 24). Dissolve the paint with water, working at with your brush until you achieve the right consistency. Paint around the shape and then fill in the center. Leave it to dry for half an hour as it needs to be completely dry. Burnish directly onto the gold with a dog-tooth burnisher.

2 The flat gouache is opaque and intense in color. Start with the red (scarlet lake, yellow ocher and zinc white) and then the blue (ultramarine blue, Winsor blue, and white). The gold detailing (bronzing) on the red is carried out freehand with shell gold used quite dry. Practice first on scrap paper.

The ribbon is laced around the initial.

Two tones of blue are used for crosshatching.

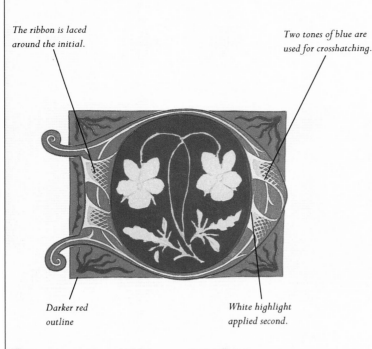

Darker red outline

White highlight applied second.

Petals of three colors

Thin wash of color

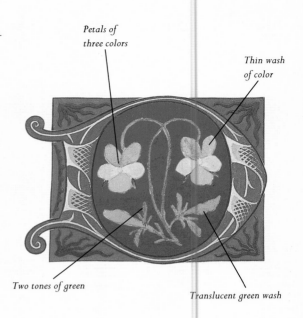

Two tones of green

Translucent green wash

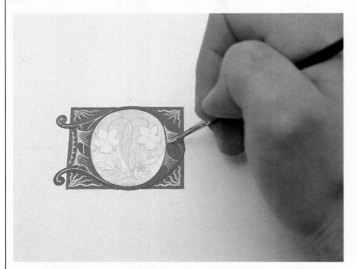

3 Highlight the original structure of the letter with white. Then outline the ribbon with a diluted wash of permanent white. Allow it to dry, then add white detailing and highlighting to the ribbon. Outline the red with Vandyke brown, and the blue with a darker mix of Vandyke brown and lamp black.

4 Wash over the leaves and stems of the pansies in two shades of green watercolor. The petal colors are purple, very pale mauve, and yellow. Dilute this first wash so that the white paper shows through the translucent paint.

Delicate hair-like strokes for
three-dimensional effect.

Reinforced with
brown outline.

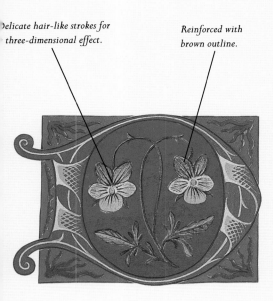

The result is highly decorative and will be enjoyed by generations to come. By painting the pansies in such a naturalistic way, the artist has taken an idea from the original manuscript and, using his knowledge of high quality examples from the period of realism, has created a small masterpiece.

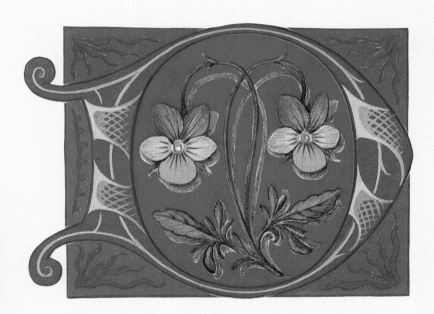

With a more concentrated mix of the flower colors, go er the leaves, stems, and als. Add shell gold centers to pansies.

6 Finally, paint shadows on the gold, creating, in a few strokes, the illusion that the pansies are lying on top of the gold ground. Use Vandyke brown watercolor diluted slightly to make the shadows and apply the paint in tiny adjacent strokes. You may need two layers to cover thoroughly.

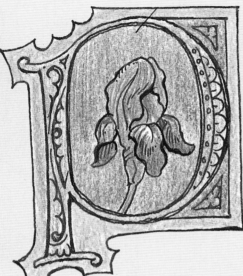

Wonderful observations of natural history emanated from the Low Countries in the fifteenth century. *Left*, a bearded iris is set within a "P," the original of which came from Flanders c.1480, and had a purple-gray background and shell gold dots.

Inspired by the naturalism of the Italian Renaissance, manuscript decoration became increasingly realistic during the fifteenth century. This realism was presented in a truly Gothic manner — often on a gold background — and tended to be isolated as a carefully observed specimen rather than part of nature itself. Many of these flowers are suggested by the iconography of the time and symbolized emotions as well as being associated with characters and incidents in the Bible. You, too, could consult a book about the language of flowers to express your feelings through your illuminated works of art.

At this time, the sale of illuminated manuscripts increased enormously, creating production-line scriptoria where such works were mass produced. The result of such production can be seen in hurried, oversimplified, and stylized illumination which you can "restore" to more imaginative and original illumination, as shown in the project.

Daisies fill this fleur-de-lys within an elegant diamond shape (*right*).

A simple sketch of a "B" (*above*) is decorated with pansies and strawberries which represented the good works of the righteous.

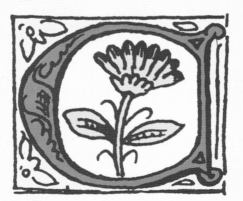

Above, a simple daisy decorates this initial "C." At this time, daisies symbolized innocence.

Below, larkspur is surrounded by a shell gold background. The letter itself could have raised gold background.

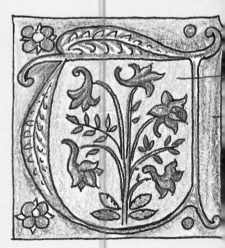

This "D," from a Rouen manuscript (*above*), c.1470, is prettily decorated with pansies.

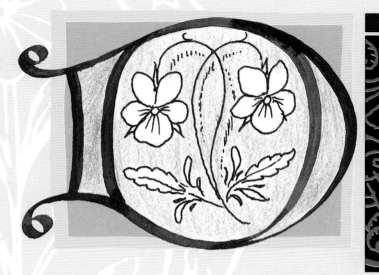

his sketch of the letter "D," (*above*) is copied from the fifteenth-century DAVID AND BATHSHEBA manuscript, which shows all the hallmarks of mass production.

Above, the rough for the project using a calligraphic Lombardic "D," with full-sized pansies.

The pansies in the original manuscript (*above, left*) were stylized, so the artist completed some natural history studies to gather information on such flowers: pansies, painted from life in watercolor and gouache (*right*); viola tricolor drawn from a natural history illustration (*far right*).

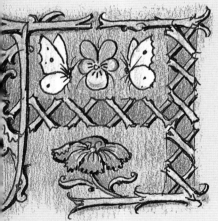

This sketch (*above*) of an initial "A" from a Flemish manuscript, c.1500, is formed with an arabesque. The trellis of twigs is of shell gold in the original.

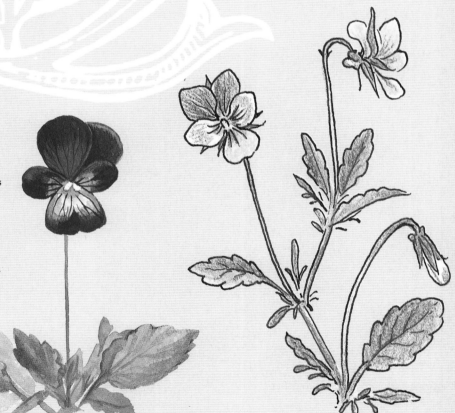

Top, a sketch of columbine and scarlet pimpernel which could be adapted to decorate an initial.

It was at the end of the fifteenth century that the peak of realism was reached in the Flemish manuscripts. These fine observations of nature were sometimes represented, as in the magnificent Flemish *Hastings Hours*, as flower-strewn borders, painted with shadows on a gold ground. The effect of such trompe l'oeil works is so complete that you feel like reaching out to see if they are real. These sketchbook pages should inspire you to try out these feats of illusionism that take the illuminator's art to its height.

A detail from the border on the opposite page (*top, left*).

Borders often incorporate carefully observed panels of natural history into more stylized patterns (*above and on the opposite page*)

Left, a sketch of an illusionistic flower-strewn border from the HASTINGS HOURS: maybe forming a complicated message using the language of flowers.

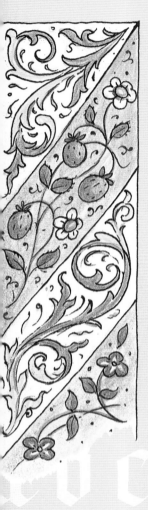

Above and right, these two borders taken from LANCELOT DU LAC depict realistic fruit and flowers.

When you enlarge illuminations using a photocopier, keep the source material close by so that you do not lose the elegant lines of your original.

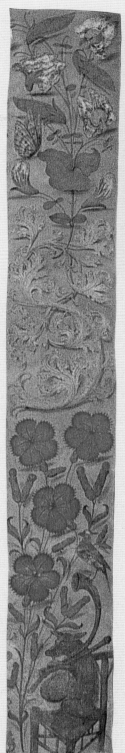

The layouts show the importance of the border: surrounding the initial, text, and miniature (*left*); enclosing the initial (*above*); forming part of the margin (*right*).

gothic

GALLERY

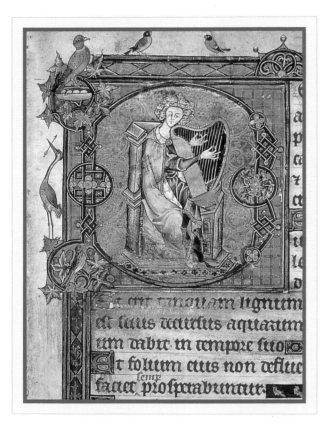

INITIAL "O" FROM THE ALPHONSO PSALTER
14th century
This Beatus initial (*above*) from Psalm I shows King David playing
his harp. The letter is formed from delicate interlace enclosing a
decorated raised gold background and is surrounded by realistic
birds – a pigeon, a blue tit, a bullfinch, and a crane.

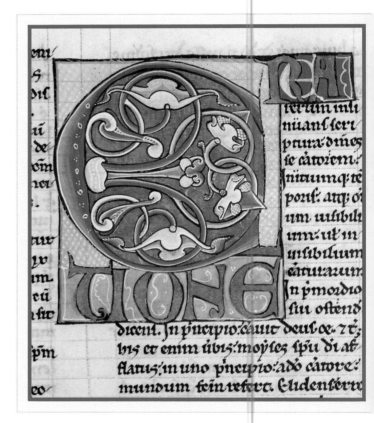

INITIAL "C" FROM PETER LOMBARD'S "SENTENCES"
late 12th century
This early Gothic initial (*above*), painted in Paris where Lombard
taught at the School of Notre Dame, is decorated with simple
plant forms and a raised gold background.

110

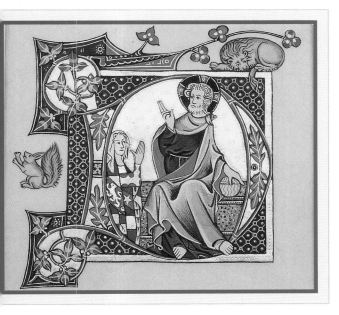

INITIAL "D" COPIED FROM
THE GREY-FITZPAYN BOOK OF HOURS
14th century

This initial "D" (*above*) shows Joan Fitzpayn wearing heraldic dress, kneeling before Christ. The letter is on raised gold, but the background of the letter itself is a rich Gothic diaper in blue and red.

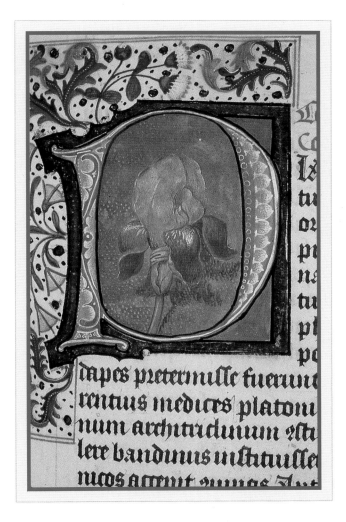

INITIALS "TO" FROM A PATENT GRANTING
BADGES TO LISTER HOWELL
BY TIMOTHY NOAD
20th century

The decoration of these initials (*above*), inspired by late Gothic illumination, incorporates shields, scepters, and coronets.

INITIAL "P" FROM PLATO'S "PHAEDRUS AND PHAEDO"
late 15th century

The iris depicted in the center of this initial (*above*) is a beautiful example of Flemish realism. The background is not gold, unusually, but a dull purplish-gray, enlivened with fine shell-gold dots. Stylized flowers – daisies, morning glories, and acanthus – are shown in the border.

renaissance

THE IDEA of a rebirth of learning, a renaissance, developed in Italy in the fifteenth century and quickly spread to other parts of Europe. In illumination, it created at first a renewed interest in classical motifs, but the manuscripts that were plundered for ideas, thought at the time to be classical Roman, were in fact Romanesque. So the Whitevine style, which quickly became the fashion, is really a development of the earlier foliated branchwork.

Alongside the Italian humanist manuscripts of the Whitevine type, which emanated from Florence in the fifteenth century, a more classical Roman style developed further north in Venice, Padua, and Verona. This was based on architectural inscriptions from ancient Rome, which were nearest to "written" sources of the period.

The effect on illumination was that initials were painted to look like inscriptions carved in stone — faceted and grooved, then intertwined with ancient Roman motifs. These motifs were taken from what was readily available, such as stone monuments to Roman military victories with standards, shields, and spears, and memorials to the heroes of ancient Rome decorated with vases and skulls. Other favorite symbols included cornucopia, dolphins, acanthus leaves, swags, and medallions.

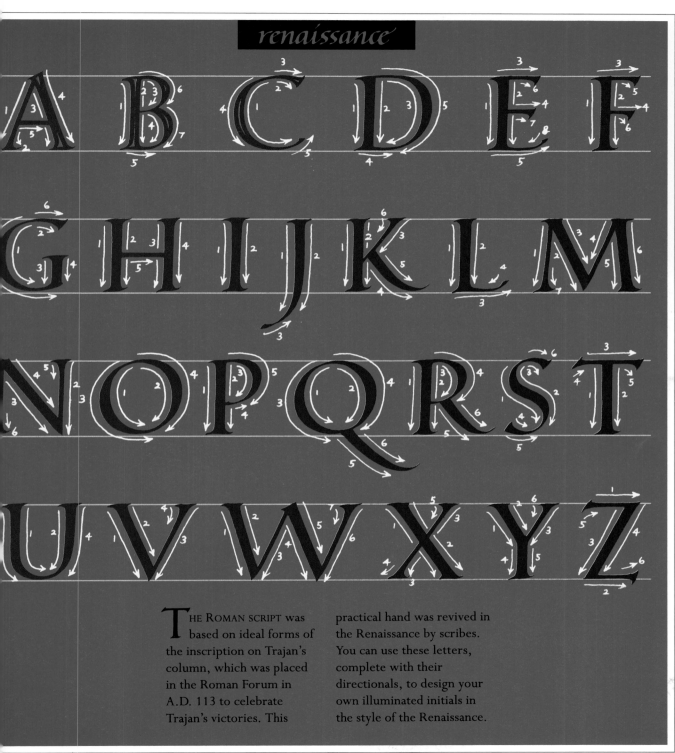

renaissance

Based on a circular "O", Roman letters may be formed with a single stroke or, as here, with double parallel strokes for the stems. The space between the parallel strokes can be filled or left unfilled. The pen should be held at a shallow angle, nearly horizontal. Letters like the "O" and the "Q" should have naturally weighted curves. Spacing is important, both inside and between letters, the "D" and the "N," for example, occupy the same area on the page. Serifs are triangular.

THE ROMAN SCRIPT was based on ideal forms of the inscription on Trajan's column, which was placed in the Roman Forum in A.D. 113 to celebrate Trajan's victories. This practical hand was revived in the Renaissance by scribes. You can use these letters, complete with their directionals, to design your own illuminated initials in the style of the Renaissance.

THE WHITEVINE STYLE

Painted in Rome in the fifteenth century, this initial "P" has been extracted from a seething mass of whitevine on a page from a classical text (Eutropius' *History of Rome*) with a decorated border and initial.

As you can see, the initial has been adapted, rather than directly copied, from the original, in which it was an integral part of the border. This adaptation meant that the artist needed to reconsider the color scheme. He tried out various color combinations on layout paper to see how they balanced with each other, before finding a formula which emphasized the curves.

The artist also chose to adapt the letter slightly using a Roman model. Although round hand was generally used for the text with this style of illumination, italic developed from the cursive way of writing round hand. The spotting is typical of the period, too, some spots painted with shell gold and burnished so that they twinkle. Note how they are painted in groups of three.

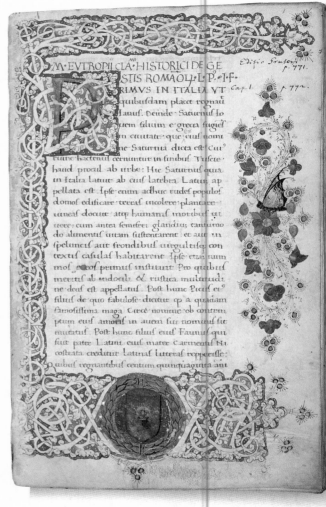

INITIAL "P" FROM EUTROPIUS' "HISTORY OF ROME"
15th century

You Will Need	
• Pencil & tracing paper	• Shell gold
• Technical pen	• Brushes – Sable 0,00
• Sepia waterproof ink	GOUACHE PAINTS
• Watercolor paper	• Scarlet lake
• Gesso	• Zinc white
• Transfer gold	• Alizarin crimson
• Glassine	• Winsor blue
• Dog-tooth burnisher	• Lemon yellow
• Double thickness loose gold	• Ultramarine blue
• Craft knife	• Permanent white
• Pencil burnisher	• Vandyke brown
• Large soft brush	• Lamp black

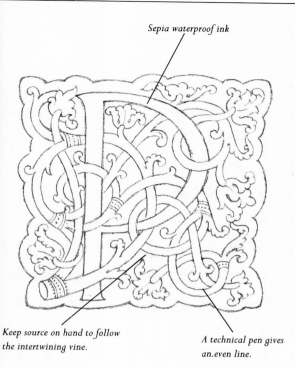

Sepia waterproof ink

Keep source on hand to follow the intertwining vine.

A technical pen gives an.even line.

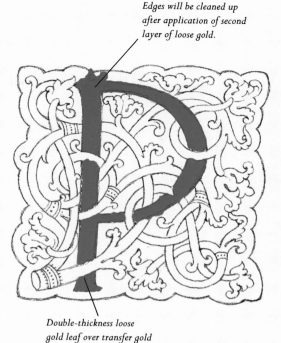

Edges will be cleaned up after application of second layer of loose gold.

Double-thickness loose gold leaf over transfer gold

T I P

With loose gold.leaf, you can fold the wasted edges around the gesso back on themselves with a piece of glassine paper or a brush. Press through the backing paper and then burnish. This improves the reflective quality of the gold and saves on wastage.

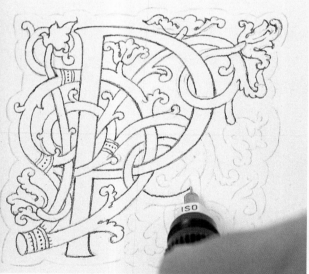

Ink in the design with sepia waterproof ink using a hnical pen. It works well for such a job as the flow is even. Apply the gesso and leave it to dry thoroughly overnight.

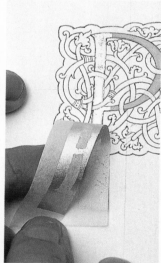

2 Press on a layer of transfer gold, and leave gesso to re-set. Burnish through glassine first, then burnish directly.

3 Add a layer of double-thickness loose gold leaf, pressing through the backing paper. If the gold will not stick, scrape the gesso gently with a knife to remove any grease, breathe on the gesso, and reapply.

When spotting, make sure the paint is wet enough to form a circular point when touched on the page with the tip of the brush. Hold the brush almost vertically.

Clean edges with a pencil burnisher.

Refer to color rough for guidance.

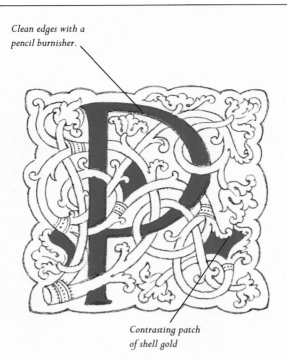

Contrasting patch of shell gold

Intense color with a little white added

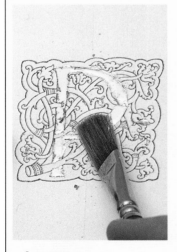

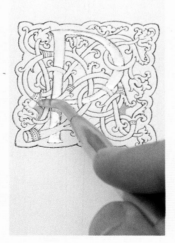

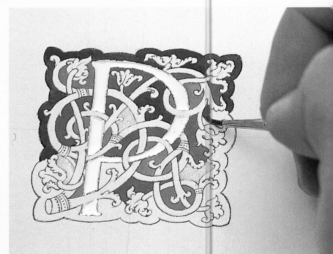

4 Burnish directly onto the gold. Add another layer and reburnish. Once you have set the edges with a pencil burnisher, remove any excess gold with a soft brush.

5 Now paint in the small patches with shell gold. Allow them to dry thoroughly and then burnish.

6 Use the intense gouache paint quite diluted, with very little white added. Paint on the red (scarlet lake, zinc white, and a touch of alizarin), then the green (Winsor blue, lemon yellow, and white) then, finally paint on the blue (Winsor and ultramarine blues and white).

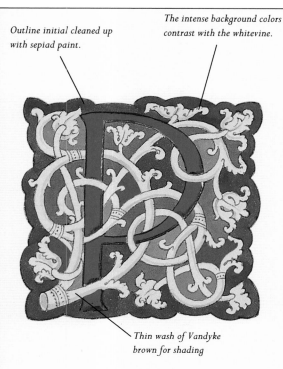

Outline initial cleaned up with sepia paint.

The intense background colors contrast with the whitevine.

Thin wash of Vandyke brown for shading

THE FINISHED LETTER

The graceful gilded "P" stands out well from the busy background. The addition of the shading adds a three-dimensional quality which greatly enhances the final result. The spotting with gold creates reflective points like stars across the solid color.

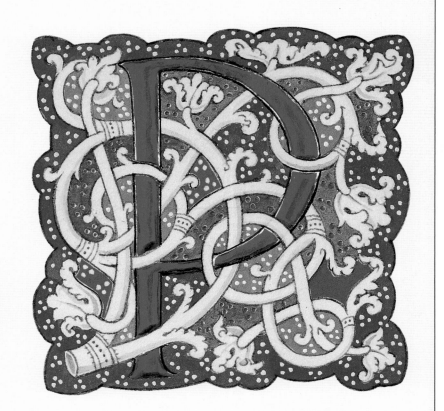

7 Paint a thin brown wash along one side of the vine and clean up the outline with a brownish mix of Vandyke brown and lamp black to match the sepia ink.

8 Use opaque permanent white and a very fine brush to white-spot the red and blue areas. Group the spots in threes, and don't make them too small. Use shell gold on the green, keeping the mix concentrated but not dry. To burnish these spots, twist the burnisher around to create a concave impression.

Renaissance illumination initially centered on fifteenth-century Florence where an enlightened bookseller, Vespasiano de Bisticci, drummed up trade in the city by building libraries for aspiring humanist scholars. Typical of fifteenth-century Florentine decoration was a style known as Whitevine, where an initial is intertwined with a creeping vine — a contrasting white against a highly colored background. Intertwining vines have always been recurring features of decoration, but this Renaissance Whitevine, often with a visible cut stem, has a solid, controlled appearance which is easily identifiable.

Whitevine does not need to be too complicated. Look at this elegant "Q," c.1450, (*above*) in which the decoration is kept to a minimum.

The artist did a color try-out for the project "P" with concentric spirals of red and green (*right*). This was rejected in favor of a design using less red (*far right*).

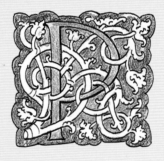

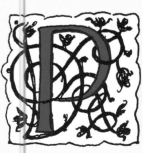

For the Whitevine "P" in the project, a Roman style initial was penned and enlarged (*left*).

This sketch (*left*) of an "S" from Pliny's HISTORIA NATURALIS, c.1460, has a gold initial that is almost lost behind the rampaging Whitevine.

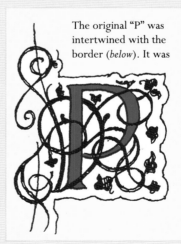

The original "P" was intertwined with the border (*below*). It was then redesigned as an integral letter which could stand on its own (*above*).

It is worth doing a quick sketch, such as this one (*below*), when you come across an interesting or new pattern.

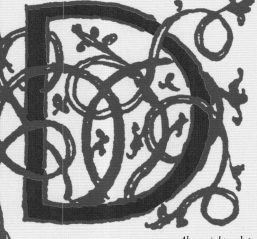

Above right, a late fifteenth-century example from Milan, which could be framed with the twisted border design (*right*) or used on its own.

An "I" can be difficult to decorate because of its simplicity. Copied from Pliny's HISTORIA NATURALIS, c.1460, this letter "I" is interlaced with Whitevine like a flailing whip (*below*).

Unlike earlier styles involving intertwining vines, the initial itself *(below and right)* remains separate from the plant life: the vine does not grow from the letter.

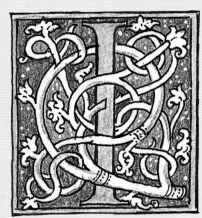

To copy this design (*far right*), begin with equally spaced points (from cross to cross) and then build up the framework of curves (*right*), connecting the spirals.

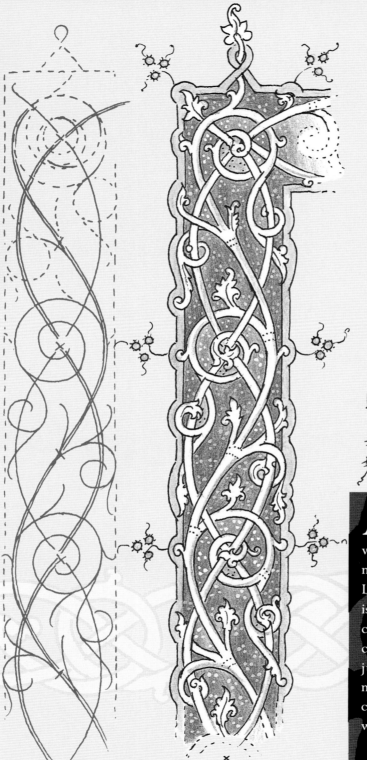

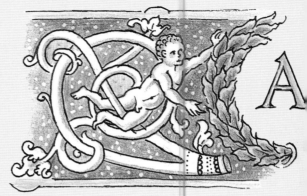

Above, a putto holds one side of a laurel wreath containing a monogram. *Below*, birds such as this parrot often hide in the foliage. A possible termination for a border (*left*).

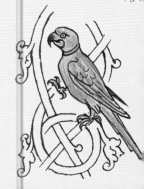

A page decorated with Whitevine can appear like a seething mass of serpents, so use this style with some restraint. Borders from this period are more enclosed and narrower than contemporary Late Gothic equivalents, and the colored background is usually given some relief with points of contrasting color or white. Painting these dots is an art in itself: cluster them in threes, otherwise, you will have to judge the spacing by eye. Humanistic cursive minuscules (*shown opposite*) combine well with Roman capitals. Fit them together on the page and decorate with all the accoutrements of the Whitevine style.

humanistic cursive

E a b c d e f
g h i j k l m
n o p q r s t u v w &
x y z æ ß ø ∴ 1 2 3 4
5 6 7 8

Try these layouts: typical Whitevine layout with the initial woven into the border (*left*); a centered design based on the name, Paolo (*right*); a horizontal layout balancing the letter with a small border (*above*).

9 0

Numerals in the Humanistic cursive style (*left*).

121

HOMER'S ILIAD

This initial comes from a copy of Homer's *Iliad,* now in the Vatican Library in Rome, and is typical of the Roman inscription style developed in the northeast of Italy in the late fifteenth century. Decorated in a truly classical way with swags, rosettes, and acanthus leaves, it is reminiscent not only of classical architectural motifs based on ancient inscriptions, but of a more decorative style, perhaps inspired by Roman wall paintings from the classical period. The Northern Italian humanists wanted to grace their ancient texts with appropriate decoration of the period without relying on later illuminated texts.

The shading of the initial, needed to imitate a letter chiseled in stone, is not as hard as it may appear; follow the steps carefully and it will be no problem. For the background, a rich orange-red is created by superimposing a broken layer of feathered red over yellow. Such optical mixing of color produces a depth and vitality that is impossible to achieve with flat color.

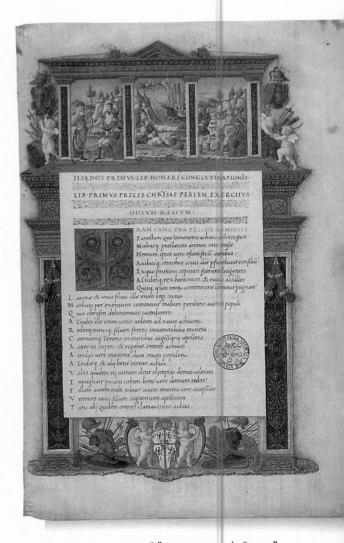

INITIAL "I" FROM HOMER'S "ILIAD"
late 15th century

YOU WILL NEED

- Pencil
- Tracing paper
- Heavy watercolor paper
- Masking fluid
- Brushes – Sable 1,00,000
- Shell gold
- Dog-tooth burnisher
- Sotf, clean eraser

GOUACHE PAINTS
- Permanent white
- Spectrum yellow

WATERCOLOR PAINTS
- Yellow ocher
- Scarlet lake
- Ultramarine blue
- Cadmium yellow
- Winsor green
- Alizarin crimson
- Vandyke brown
- Lamp black

t reserve enough masked space to work on.

The design was squared up and enlarged by the artist.

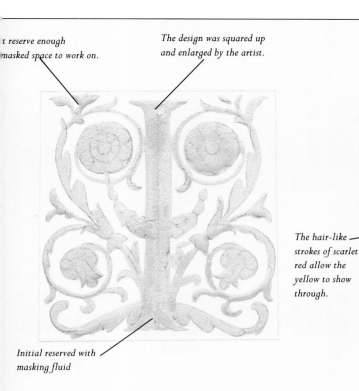

Initial reserved with masking fluid

Yellow masking fluid

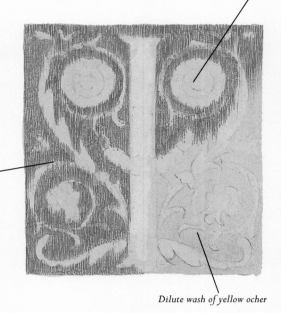

The hair-like strokes of scarlet red allow the yellow to show through.

Dilute wash of yellow ocher

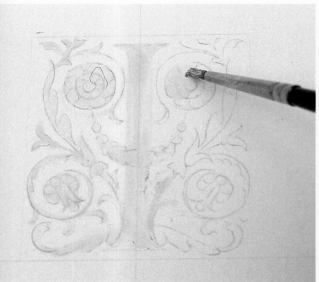

Transfer the design to a piece of tracing paper before acing it onto white watercolor per. Reserve the initial and its decorative features with a layer of masking fluid.

2 Once the masking fluid is dry, paint on the first layer of the background color – use a dilute wash of yellow ocher watercolor. Leave this to dry for ten minutes.

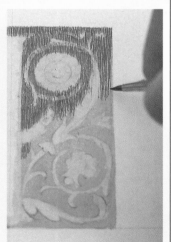

3 Apply the second layer to the background – a rich scarlet red, which is applied using a feathered technique of small hair-like strokes which do not quite interlock.

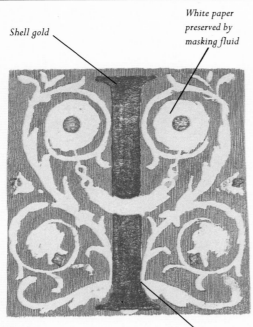

Shell gold

White paper
preserved by
masking fluid

Cleaned up by outlining
in brown later.

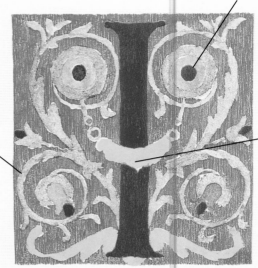

Very pale wash
of alizarin
crimson

First layer of
flat paint

Decorat_
swag

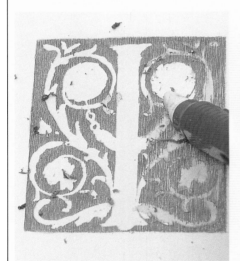

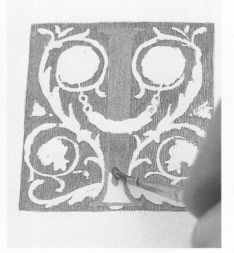

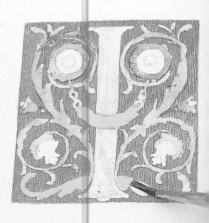

4 When the paint is quite dry, rub off the
masking fluid with a soft, clean eraser.
Brush the area with a clean soft brush; using
your fingers may transfer grease to the paper.

5 Paint the initial and flower centers with
shell gold, beginning with the outline,
then filling the center. Burnish the gold when
it is quite dry.

6 Paint in the first layer of flat paint for
the decorative spirals and swags, using
two tones of blue (ultramarine blue and
mauve); yellow (cadmium yellow and a touc_
of Winsor green) and pink (alizarin crimson)

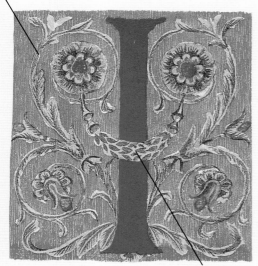

...ails added in
...rker shades.

*Shading gives form
to these decorative
features.*

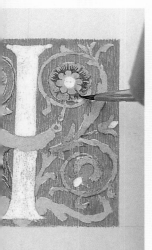

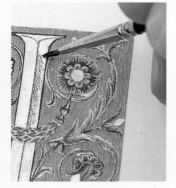

7 Allow the first layer to dry
and then add shading in
...ker tones of the colors used.
...e delicate feathered strokes.

8 Use a fine 00 brush and
Vandyke brown with a little
added lamp black for the outline.
For the shading on the initial,
take the direction of the light
from above and to the left with
medium hatching on the right.
Finally, add highlights of
permanent white and spectrum
yellow to the leaves and flowers.

THE FINISHED LETTER

Looking at the completed illumination, you can imagine
such an initial gracing its classical text and being
cherished by bibliophile collectors of the Renaissance.
It has a symmetry and rhythm which make it easy to
adapt for any use.

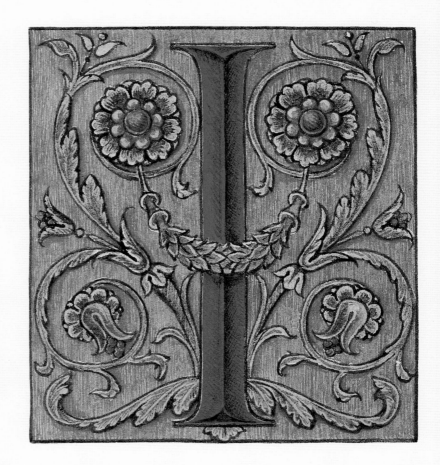

This stone wheel (*above*) is from the entablature of a classical fifteenth-century building.

Realistic jewels and a cameo painted trompe l'oeil decorate this letter from fifteenth-century Venice (*below*).

A panel of initial letters enclosed in colored squares, based on an original patterned in white and gold.

This simple "V" (*right*) has unmistakable classical origins based on decorative relief work.

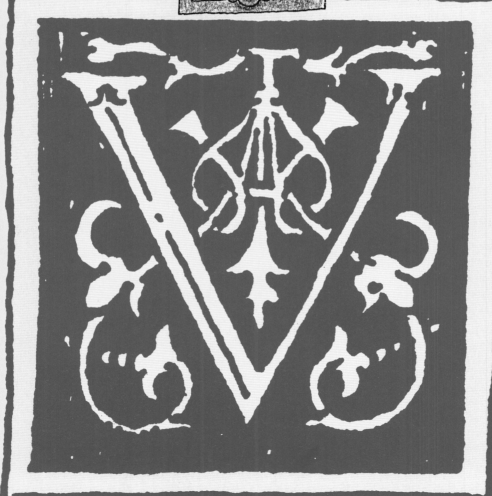

Although the Florentine Whitevine style of illumination spread throughout Italy in the fifteenth century, in the northeast of Italy, a local style emerged. Perhaps realizing the problems of basing their illumination on genuine classical examples, rather than reproducing more recent copies in the manner of the Whitevine, illuminators of the time used sources they knew were genuine — classical Roman inscriptions. The lettering for this style is painted as if chiseled into the stone, and the ornamentation complements it in a dignified manner without engulfing it. Try this style for your own illuminations.

The ox skull and tassels (*right*) would be found on classical monuments. Such motifs were painted trompe l'oeil to imitate stone work.

Above, three cherubic figures decorate the Roman "V." *Below*, delicate plant tendrils decorate this initial "A" from sixteenth-century Paris.

Prettier versions of the Roman style from sixteenth-century France (*left and right*); with dolphin head (*above*).

Left, delicate penwork decoration. *Right*, simple plant forms decorate this "F."

Dolphins, a favorite classical motif, carry this winged spirit of the wind (*right*). The design is symmetrically arranged.

Trompe l'oeil parchment is surrounded by architectural motifs (*below*).

The classical style appears ordered and restrained next to the Whitevine style. Here, a Roman candelabra design decorates a border (*right*).

Short brushstrokes shading surrounds this candelabra design surmounted by cornucopia, (*right and below*).

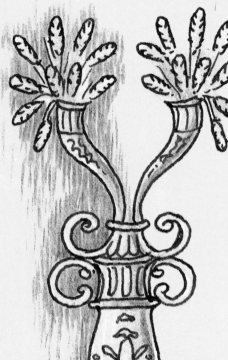

Illusionistic gemstones are often included the design (*left*

These sketchbook pages show how the classical motifs which made up the vocabulary of this fifteenth-century Roman revival in northeastern Italian illumination was highly suitable for the decoration of classical texts. Many of the ideas for these motifs came from surviving Roman classical architecture and other works in stone. The success of this style depended on the painted shadows, which create a three-dimensional illusion. Such ornament was originally carved on stone monuments so they were painted as if in relief on the vellum. Construct your own architectural borders using elements from these examples. You could combine them with interesting features from buildings of your choice.

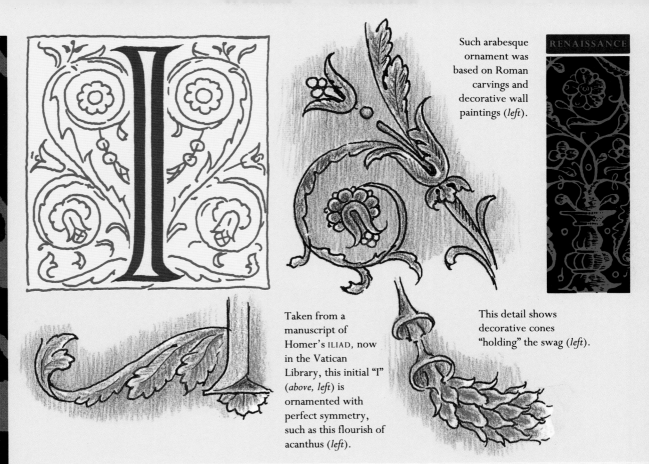

Such arabesque ornament was based on Roman carvings and decorative wall paintings (*left*).

Taken from a manuscript of Homer's ILIAD, now in the Vatican Library, this initial "I" (*above, left*) is ornamented with perfect symmetry, such as this flourish of acanthus (*left*).

This detail shows decorative cones "holding" the swag (*left*).

RENE

Try these different Renaissance-style layouts for your own illuminations.

renaissance

INITIAL "M" FROM NICCOLO SAGUNDINO'S
"ON THE DEATH OF VALERIO MARCELLO"
late 15th century
This Roman initial "M" (*above*) has been carefully highlighted to
create a three-dimensional effect. Decorative leaf-like terminations
suggest a peeling layer of antique gilding.

ILLUMINATED PAGE FROM VIRGIL'S "AENEID"
late 15th century
This initial "A" (*above*) has been painted to look like a three-dimensional
carved letter. The background is decorated with antique arabesques, plant
forms, and a double-bodied beast, perhaps a lion, with one head.

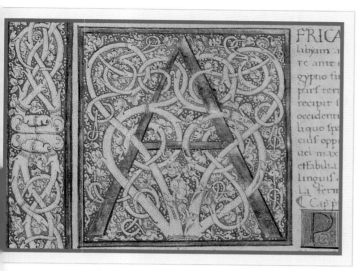

INITIAL "A" COPIED FROM PLINY'S "HISTORIA NATURALIS"
mid-15th century

This gilded Roman initial "A" (*above*) is richly interlaced with spiraling
Whitevine, with its characteristic bright colors and spotted background.

TAIL FROM A PATENT GRANTING ARMS TO P. LITHERLAND
BY TIMOTHY NOAD
20th century

e decoration of the border shown in this extract (*above*) was inspired by
enaissance Whitevine illumination. The initials "TO" are picked out of
the neutral background by colored and gold dots.

INITIAL "I" FROM A PATENT FOR THE SOVEREIGN
ORDER OF THE OAK BY ANTHONY WOOD
20th century

The illumination of the initial "I" and text (*above*) was inspired by
the Italian Renaissance; shell gold Whitevine interlaces the "T" and
the filigreed ornament is in raised gold.

modern revival

CONTEMPORARY illumination thrives in many quarters. Fine work is carried out in the name of heraldry and genealogy, but the art also lives on in many other areas. These include, for example, commissions for written and illuminated poetry, for inscriptions in books, for embellished quotations, for commerce and advertising, and for works of art where script and illumination are combined to be appreciated for themselves alone.

With the impetus generated by the Arts and Crafts movement, in particular by William Morris and the Kelmscott Press he founded in 1890, it was only in this century that the techniques of the medieval illuminators were fully restored to use, having lain dormant for almost two hundred years. Artists wishing to explore the art of gilding found themselves returning to such medieval texts as the craftsman's handbook by Cennino Cennini, *Il Libro dell'Arte*, written in the fourteenth century.

Modern technology has not changed the lot of the illuminator very much, and perhaps this is how it should be. There is no doubt that a large part of the pleasure illumination gives comes from the gradual mastering of the technical and manual skills involved – a palliative to the busy, noisy, rushing nature of the world today.

MODERN VERSALS

A B C D E F G

H I J K L M N

O P Q R S T

U V W X Y Z

Use a pen, held at an angle of about 25°, to form the Modern Versals. The letters may slope slightly forward if desired. Use two parallel strokes for the stems and curves, filling the space between the strokes. The main stems are very slightly waisted, widening at the top and base to form slight wedged serifs. The curves of the letters "O" and "Q" are naturally weighted, so that the thickness of a curve on one side of the letter is mirrored on the other side.

The width, height, and weight may be manipulated as long as they remain consistent.

T HESE MODERN VERSALS, generated by the Arts and Crafts Movement in the late nineteenth century, are formed like the earlier Versals, but are more practical in style. There is an uncluttered nature to the lines. Use these letters to design your own illuminated letters in the style of the Modern Revival.

WILLIAM MORRIS' DEDICATION

In 1873, William Morris, the prime mover behind the Arts and Crafts movement, translated the *Icelandic Sagas*. These he inscribed and illuminated in the Whitevine style, dedicating them with this monogram in his own original style to Georgiana Burne-Jones who was a close friend.

This monogram has been greatly enlarged from the original. Enlarging may cause problems with the spacing between the letters – the intertwining flower decoration makes this easier to adjust. With enlarging, you may also lose the purity of the line of the original letters, if so, start again, penning your own letters.

The use of silver leaf in this example is stunning. Silver leaf is rarely used for illumination, since it will tarnish if left in the open air. You can preserve some of the original brilliance if the work is part of a book which will remain closed, or if it is framed behind glass, but remember that tarnished silver has a beauty all its own.

INITIALS "GBJ" FROM WILLIAM MORRIS'
TRANSLATION OF THE ICELANDIC SAGAS
late 19th century

YOU WILL NEED

- Pencil
- Tracing paper
- Watercolor paper
- Gesso & craft knife
- Brushes – Sable 0,000
- Dog-tooth burnisher
- Transfer gold leaf
- Glassine
- Loose silver leaf
- Loose gold leaf
- Large soft brush

WATERCOLOR PAINTS
- Ultramarine blue
- Cerulean blue
- Winsor blue
- Lemon yellow
- Alizarin crimson
- Zinc white
- Vandyke brown
- Lamp black

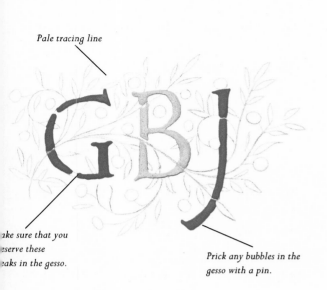

Pale tracing line

Make sure that you preserve these breaks in the gesso.

Prick any bubbles in the gesso with a pin.

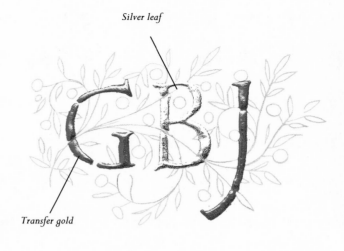

Silver leaf

Transfer gold

Use a rolled tube of cardboard to channel your breath more accurately, and with more strength, at the gesso.

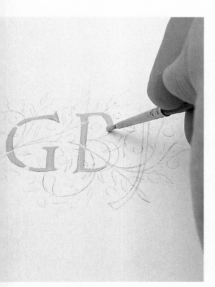

1 Apply the gesso to the three traced initials. (Any small bubbles of air will in your gilding, so deal with them at the tset, see pp 27.)

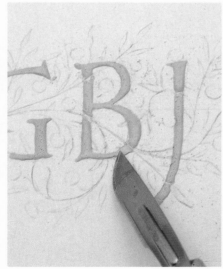

2 Dry the gesso overnight, then smooth any imperfections with a craft knife. Don't scrape it, just let the weight of the knife do the work for you.

3 Burnish the gesso of the two outer initials lightly. Breathe on it (see Tip), press on the transfer gold, and allow it to set. Burnish the gold. Mask off these two outside initials with glassine and cut a piece of loose silver to fit the center initial. (Silver leaf does not stick to itself so only one layer is needed.) Apply the silver and burnish in the same way as for the loose gold, and brush away excess.

If, when you have drawn your initials, you find the spacing unbalanced, this can often be redresssed by clever use of decoration.

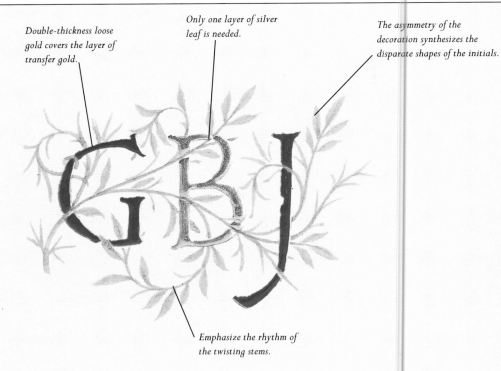

Double-thickness loose gold covers the layer of transfer gold.

Only one layer of silver leaf is needed.

The asymmetry of the decoration synthesizes the disparate shapes of the initials.

Emphasize the rhythm of the twisting stems.

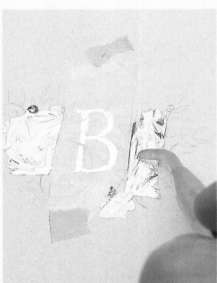

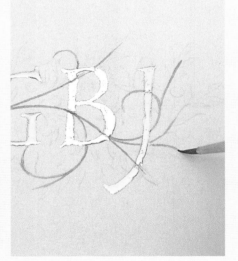

4 Breathe on the outside letters, then add a layer of loose gold, protecting the silver with glassine. Burnish, once set, and brush away excess gold.

5 Use a mixture of green watercolor to paint the twisting stems. The asymmetry of the stems helps to synthesize the disparate shapes of the initials.

6 With the same pale green, add the leaves, using the underdrawing as a gui but relying on your eye for the rhythm.

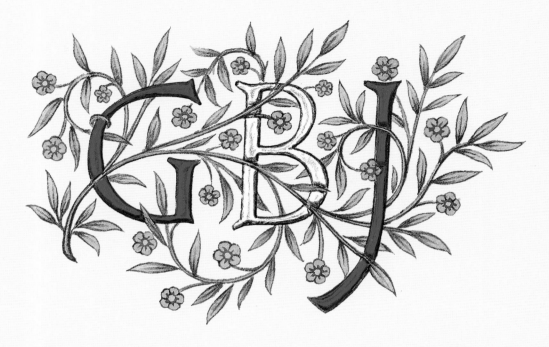

THE FINISHED LETTER

Graceful and decorative, this design draws on ideas from medieval illumination but has a style which marks it as Arts and Crafts, and particularly from the hand of William Morris. The contrast produced by the juxtaposition of the gold and silver is worth the extra trouble required. Try substituting your own initials, but use your eye when arranging the twining leaves, so there is a natural balance.

7 Having added the flowers in pink and blue, shade the leaves and stems in a darker green. Use the brush to make the tapering shape, emphasizing twisting curves of the stems.

8 Now to reinforce the design and clean up any untidy edges, the outline is painted with an even darker shade of the original colors for the leaves and flowers. Use a mixture of Vandyke brown and lamp black to outline the initials.

This raised silver "G" (*above*) has been sketched from a copy of the RUBAIYAT OF OMAR KHAYYAM, 1872.

Above, a "Y" taken from A BOOK OF VERSE, 1870, and illuminate by William Morris.

The Arts and Crafts Movement began in late Victorian England as a reaction to the low standards generated by mass production. By the end of the century, its aim to produce well-made, well-designed everyday furniture and artefacts was recognized as having failed, but the inspiration of the movement spread to Germany and also to the United States, where it flourished until World War I. Skills for illumination were revived by William Morris, leading to renewed interest in calligraphy and illumination of the past. Medieval scripts and motifs were resuscitated in this eclectic style, which you could try using in your own illuminations.

A monogram in a script typical of the time known as swash letters (*below*).

A monogram "CFS" in Victorian style (*above*).

Pierced Gothic style "H" with a treatment that marks it as Arts and Crafts (*left*).

...re, italic capitals have been ...corated with a design inspired ...William Morris (*above*).

...bove and right, decorated ...pitals taken from A BOOK ...F VERSE which are easily adapted.

Perfectly combined and balanced, a monogram "HA," in Tudor style (*below*).

Experiment with your lettering. This graceful "I" has a fanciful oblique base which makes it unique (*left*).

This enlarged detail shows the two shades of green used in the project (*left*).

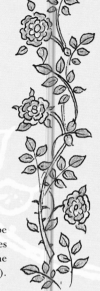

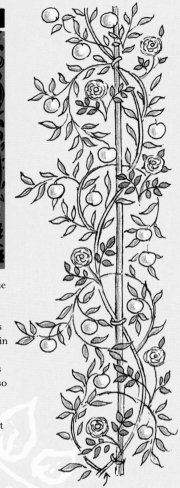

A nice touch, the stem is "tied" to the frame at regular intervals (*right*). Painted in watercolor, the roses and apples are distributed so that the patches of color are balanced but not rigidly symmetrical.

This sketch (*left*) shows the basis and repeat element of the design (*far left*). Note how the design is extended to interlock with the unjustified edge of the text.

Decorative borders can be combined, as with the roses and apples, or used alone (*right and below*).

The project monogram was enlarged by squaring up the image (*right and far right*). Shading squares and contrasting colors helps isolate each section (*see also p31*).

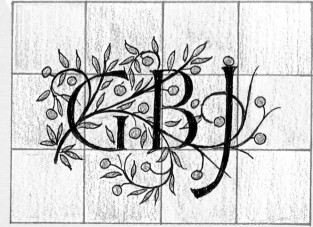

Adaptations of earlier styles: spiraling acanthus edged with gold against a spotted background (*above*); a border in the Whitevine style with exaggerated leaves (*top right*).

Clearly penned initials will help you judge the spacing (*right*).

GBJ

formal italic

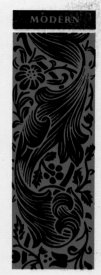

a b c d e
f g h i j k l m n o p
q r s t u v w x y z
æ ß ø ∴ ,;

Design the layout of your page in the manner of the Arts and Crafts Movement, adapting it to your needs. Use the alphabet (*above*) to form your lower-case letters.

& 1 2 3 4 5 6 7 8 9 0

William Morris set up his design and manufacturing company, Morris, Marshall, Faulkner & Co., in 1861 with Edward Burne-Jones, Rossetti, and others. Burne-Jones' wife, Georgiana, inspired some of Morris' best work in illumination – *A Book of Verse* in 1870 and a translation of the *Norse Sagas* in 1873, from which the monogram in the project was taken. The highly decorative free-ranging borders shown on this page come from the former publication and can be adapted to any unjustified right-hand edge of text. With such naturalistic borders, you need to establish the basis of the design – the twisting stems – and then fill in the leaves freehand. Combine your initials with the modern formal italic letters shown opposite.

Original layout of the illuminated monogram (*left*). It would be given more prominence in a simple layout, with inscription beneath (*right*).

You could incorporate the monogram into an elaborate border (*right*) or interlock it into a naturalistic one (*far right*).

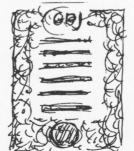

THE HOROSCOPE INITIAL

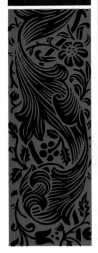

This combined initial and star sign is a stunning example of contemporary illumination, and was designed and illuminated by the co-author of this book.

The problems which arose while designing the piece involved a desire to combine a blue background, alluding to the sky, and the fiery colors associated with the Scorpio zodiac sign. The artist did not want the background color to be too heavy, rather more atmospheric, so sponging seemed the obvious answer. This meant using masking fluid and gilding after painting, which could have caused problems with the loose gold adhering to the paint surface. Creating a broken surface, however, ensured that this did not happen.

The artist also considered gluing an opal (the Scorpio birthstone) in the claws of the scorpion, but thought it would lack contrast. All these considerations and others were carefully worked out in roughs.

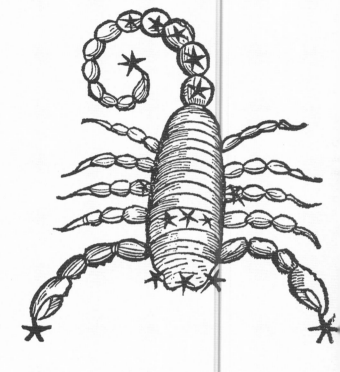

This sixteenth-century woodcut depicts a scorpion, the symbol of the Scorpio sign of the Zodiac. Together with a number of other astrological references, this picture was a major influence on the Horoscope Initial "A," designed and created by Timothy Noad.

YOU WILL NEED

- *Pencil*
- *Watercolor paper*
- *Brushes — Sable 0,00*
- *Masking fluid*
- *Fine, old brush*
- *Small, natural sponge*
- *Soft, clean eraser*
- *Gesso*
- *Glassine*
- *Transfer gold*
- *Loose gold leaf*
- *Dog-tooth burnisher*
- *Pencil burnisher*
- *Silver leaf*
- *Pan gold gouache*
- *Shell gold*
- *Large, soft brush*

GOUACHE PAINTS
- *Ultramarine blue*
- *Zinc white*
- *Vandyke brown*
- *Yellow ocher*
- *Scarlet lake*
- *Permanent white*

Precise drawing is needed.

Masking fluid

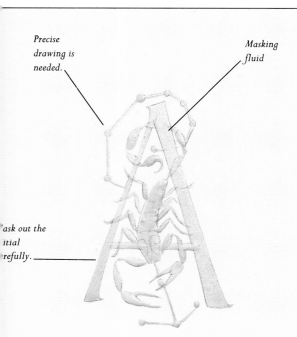

ask out the itial refully.

Sponge over the masking fluid.

You can build up the tone by superimposing impressions.

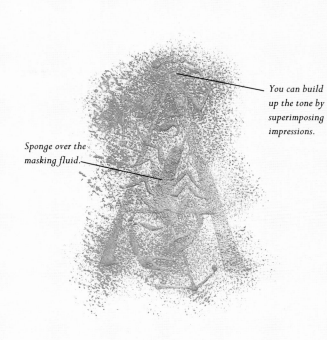

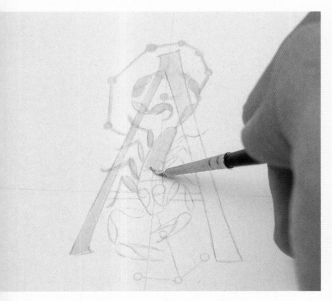

Paint on the masking fluid, using a fine, old brush. Wash e brush in warm water. Take re to mask out the initial,

scorpion, and stars exactly, following the precise drawing.

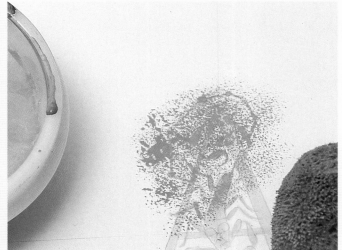

2 Mix a quantity of blue gouache (ultramarine with zinc white and a touch of Vandyke brown to dampen brightness). It should have the consistency of thin cream. Use

a small, dry natural sponge to apply the paint, first trying it out on rough paper so that the print is quite faint.

Preserved white paper

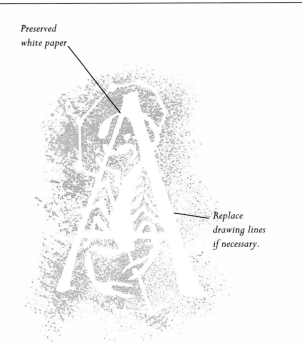

Replace drawing lines if necessary.

For the stars, apply a dab of gesso and then tease out the points.

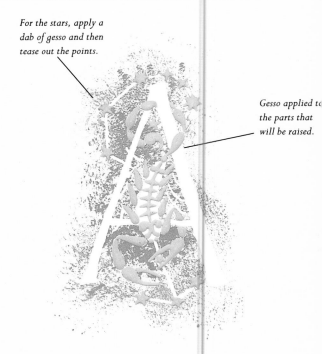

Gesso applied to the parts that will be raised.

3 When the paint is dry, carefully rub off the masking fluid with a soft eraser without disturbing the paint. Three types of gold were used for the scorpion to give contrast: raised gold for the back and upper legs, pan gouache for the main body, and shell gold for the end section of the legs.

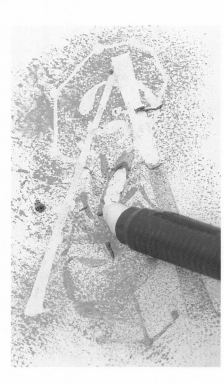

4 Apply gesso on the parts of the design that are to be raised (see pages 27-8 for the technique). The stars are quite difficult, so you would be wise to practice first. Apply a dab of gesso, teasing out the points, and then add more to the center.

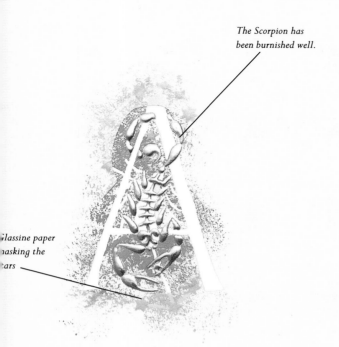

The Scorpion has been burnished well.

Glassine paper masking the stars

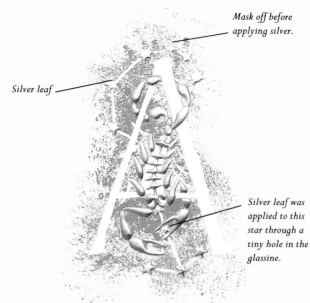

Mask off before applying silver.

Silver leaf

Silver leaf was applied to this star through a tiny hole in the glassine.

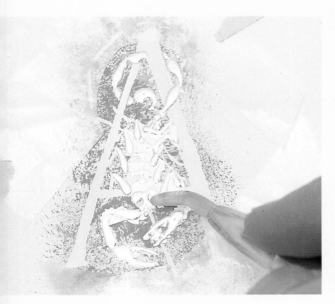

Mask off the stars with a piece of glassine and apply the first transfer, then loose gold (see page 25). Burnish between layers, "cutting" away from the edges with the pencil burnisher.

6 Now apply the silver leaf onto the stars. Mask around the star in the apex of the "A" to stop the silver from sticking to the gold. Similarly, with the star in the claws of the scorpion, cut a tiny hole in the glassine and apply the silver through it.

TIP

To try out various fiery colors for the initial, cut out painted paper lengths of the various options, hold them against the letter, and view with your eyes half-closed.

Premix the scarlet, yellow ocher, and their combined undertone in your palette, ready to feed in wet-in-wet once the initial wash is laid on.

Pan gouache – a red gold – for the main body

Shell gold for the end sections of the legs

Raised gold leaf

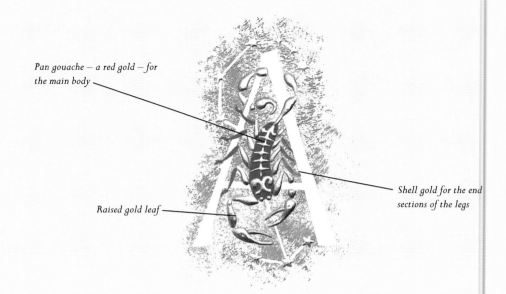

7 Having used a red gold pan gouache for the main body, apply shell gold to the end sections of the legs. The reddish pan gold contrasts well with the flatter shell gold and more reflective gold leaf.

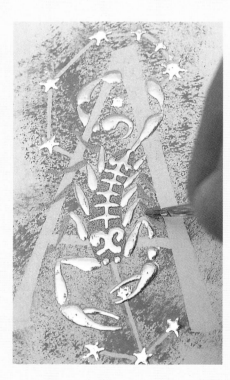

8 The artist tried out various combinations of fiery colors for the initial (see Tip). He arrived at a combination of yellow ocher, scarlet lake, and white to make it opaque, grading the colors in the palette. Cover the whole letter in a medium color wash and then feed in the opaque extremes of color wet-in-wet from the top (scarlet lake) and base (yellow ocher) of the letter, so that they meet in the middle.

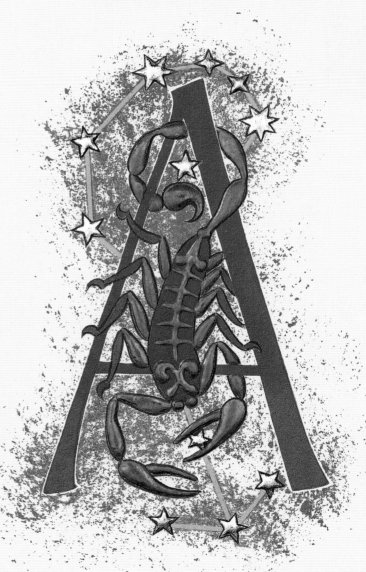

e white outline
und initial

Blue outline helps
articulate the legs of
the scorpion.

THE FINISHED LETTER

The result is stunning. Using the three types of gold and silver leaf gives the work a richness which, combined with an original design and a freshness, gives an entirely contemporary feel to the illumination. This piece will be framed behind glass as soon as possible to prevent the discoloration of the silver leaf.

A fine outline of permanent white helps the initial to nd out clearly against the blue the background.

10 Outline the scorpion and stars in a mix of Vandyke brown and ultramarine to clean up edges and redefine the design.

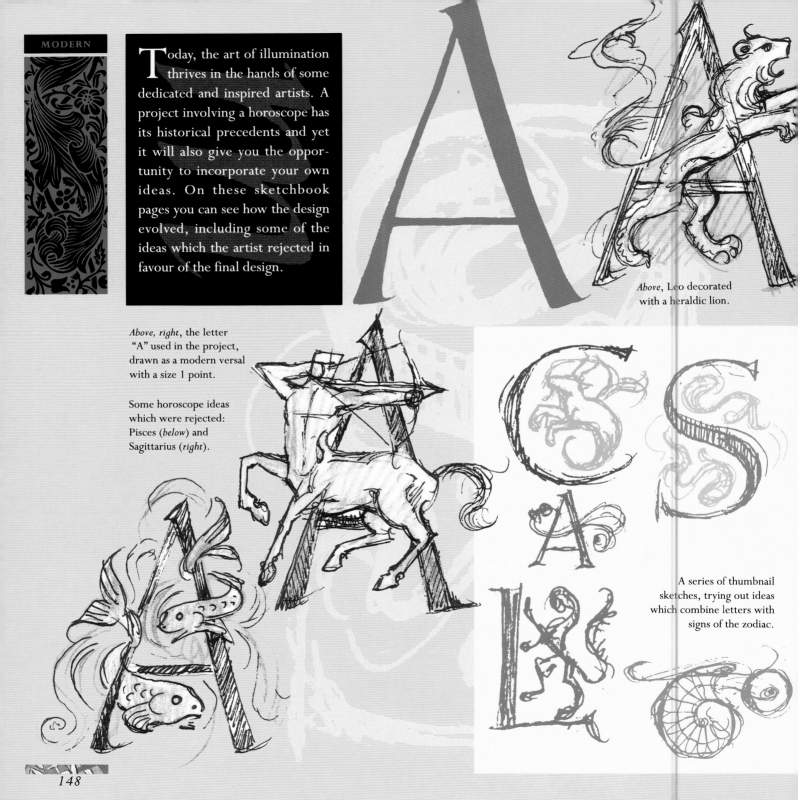

Today, the art of illumination thrives in the hands of some dedicated and inspired artists. A project involving a horoscope has its historical precedents and yet it will also give you the opportunity to incorporate your own ideas. On these sketchbook pages you can see how the design evolved, including some of the ideas which the artist rejected in favour of the final design.

Above, Leo decorated with a heraldic lion.

Above, right, the letter "A" used in the project, drawn as a modern versal with a size 1 point.

Some horoscope ideas which were rejected: Pisces (*below*) and Sagittarius (*right*).

A series of thumbnail sketches, trying out ideas which combine letters with signs of the zodiac.

Gathering information for the Scorpio design involved sketching a scorpion from a natural history book (*right*).

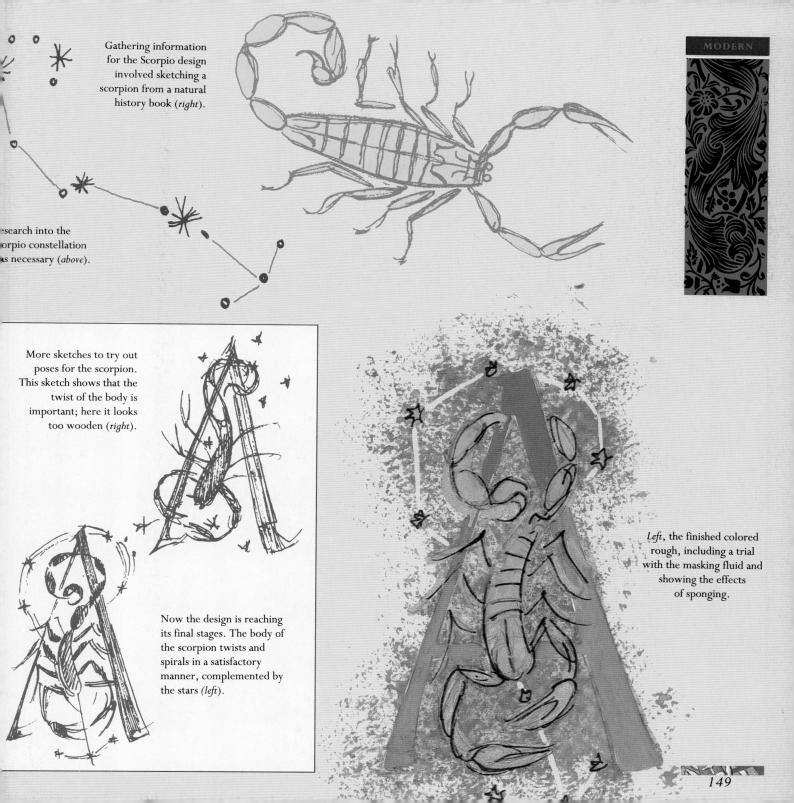

esearch into the orpio constellation s necessary (*above*).

More sketches to try out poses for the scorpion. This sketch shows that the twist of the body is important; here it looks too wooden (*right*).

Now the design is reaching its final stages. The body of the scorpion twists and spirals in a satisfactory manner, complemented by the stars (*left*).

Left, the finished colored rough, including a trial with the masking fluid and showing the effects of sponging.

149

These sketchbook pages show more ideas that you can adapt for illuminating horoscope initials. You may prefer to use a free and abstract style, as in the Aquarian "R" (*below, left*) or a more ordered and symmetrical style, as shown in the Taurean "H" (*below*). This is an opportunity to use your imagination to combine ideas from the past and the present and use new skills to create stunning and original effects.

Signs of the zodiac can be created from material gathered from contemporary life or based on historical precedents.

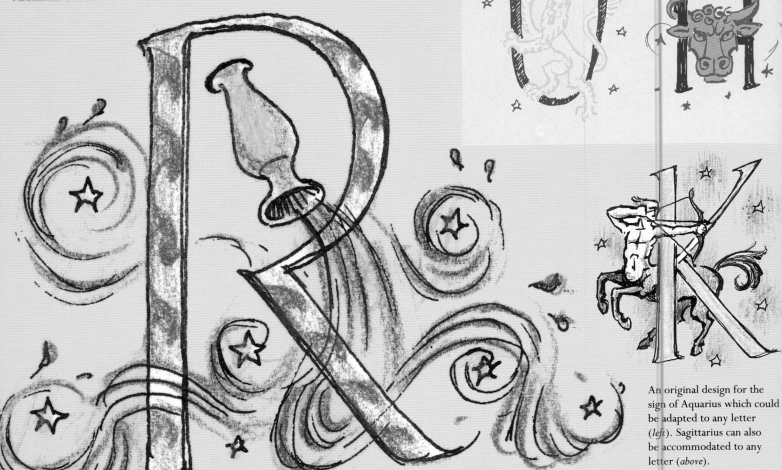

An original design for the sign of Aquarius which could be adapted to any letter (*left*). Sagittarius can also be accommodated to any letter (*above*).

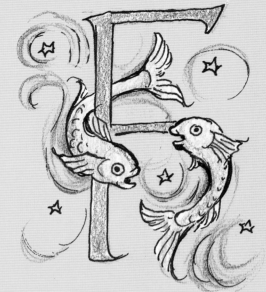

Above, an offbeat idea with italic script written at an angle to the "A." *Right*, the maritime theme inspired by Pisces could be incorporated throughout the decoration of the page.

Above, this fish would liven up a Pisces illumination. *Below*, a layout for a quotation.

By alternating contrasting bands of upper and lower case letters, the page is given an interesting structure (*above*).

Above, here the artist is playing around with different "textures" of script – capitals and minuscules arranged around a central axis. *Left*, the star theme is picked up in the smaller capitals of the name.

151

INITIAL "T"
BY MARIE ANGEL
20th century
This delicately painted initial
(*above*) shows a naturalistic
mouse perched on a Roman
letter "T." The curve of the
mouse's tail intertwines the
main stem of the initial.

**INITIAL "E" FROM A
CROWN OFFICE PATENT**
BY MARGARET WOOD
20th century
This initial "E" (*left*), which
begins the name of the
Sovereign, encorporates
elements from the Royal Arms.
The letters that complete the
name are Lombardic versals.

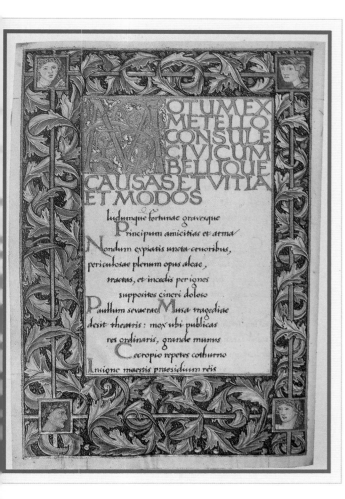

The rich decoration of this page
(above) is Renaissance in style, but
e abundant, colorful foliage is
ypical of Morris. Acanthus leaves
iral around the gold bars of the
me, while the Roman initial "M"
interwoven with golden vines.

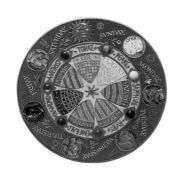

ILLUMINATED PANEL BY TIMOTHY NOAD
20th century
This illuminated miniature (*above*) of a cat, Pandora, has a
background of contrasting squares of flat and raised gold.

ILLUMINATED PANEL BY TIMOTHY NOAD
20th century
Originally this heraldic illumination would have featured the names
of colors. Here, the artist has substituted the names of the days of
the week.

GLOSSARY

Ascender
In calligraphy, the stroke which ascends above the height of the lower-case letters.

Base
The medium used to adhere loose gold onto vellum or paper – gesso, size, or white glue.

Bestiary
A natural history book, popular in the twelfth and thirteenth centuries, containing tales about animals, both real and imaginary.

Burnish
To polish or shine. In illumination, a burnisher (*see below*) is used on the gold to achieve maximum reflectivity and smoothness.

Burnisher
A smooth-ended tool, formerly a dog-tooth or agate, now made of hard, smooth plastic or mineral.

Carpet page
Ornamental page of decoration, often cross-shaped, found in Celtic gospels.

Cursive
Informal style of script, with the letters linked. Used for letters and documents rather than manuscripts.

Descender
In calligraphy, a stroke which carries on below the height of the lower-case letters.

Diaper
To decorate with a small uniform pattern – often used for the background to a scene or in the depiction of drapery.

Gesso
A mix of fine plaster and adhesive, which is used as a base to bind loose gold to the support in raised gilding.

Gloss
A commentary written next to a text.

Gouache
Water-based, opaque paint often used in contemporary illumination instead of traditional tempera.

Gum arabic
A type of gum, added to powdered gold as a binder.

Gum ammoniac
A resin, purchased in crystal form, which is melted down with hot water to make size, the traditional base for flat gilding.

Gum sandarac
A resin used as a fine powder in the preparation of vellum for calligraphy and illumination.

Half uncial
A script using ascenders and descenders with the pen held at a slanted angle.

Historiated initial
An illuminated initial where the void of the letter is painted with a scene relevant to the passage it heads.

Insular
Refers to work produced in the British Isles c. 550-900.

Interlace
A type of pattern where several lines or bands are plaited over and under each other.

ose gold
old beaten into delicate fine sheets,
pplied to a base in gilding.

ajuscule
pper-case script

inuscule
ower-case script incorporating ascenders and descenders.

apyrus
arliest form of support (*see right*), made from the stem of
e papyrus plant.

archment
eep or goat skin prepared to make a delicate support for
lligraphy and illumination.

ounce
fine abrasive powder which is used to prepare vellum
r calligraphy.

owder gold
ure gold, sold by the gram, which has been ground to a
wder. It is mixed with gum arabic and used for
umination.

VA
lyvinyl acetate, or white, glue, which can be used as a
se for raised gilding.

ubrication
To emphasize part of the text in red. It is used in
this book to describe the application of rows of
red dots around the outline of illuminated letters
in the Insular style.

rif
e strokes which end the main strokes of a
ter, sometimes wedged or hooked.

Shell gold
Powder gold combined with gum arabic and allowed to
harden in a pan (originally sold in half a mussel shell).

Size
Traditional base for flat gilding

Support
The material used as a surface for calligraphy and
illumination – paper, vellum, or parchment.

Tempera
A medium consisting of ground pigment and egg yolk,
diluted with water.

Transfer gold
Sheets of gold manufactured as a transfer (i.e., with a
backing sheet).

Trompe l'oeil
An illusionistic representation of a subject on the two-
dimensional page which deceives the eye into thinking that
it is threedimensional.

Uncial
A script used in manuscript writing by the
Romans and Celtic peoples, such as
Celtic uncial.

Vellum
Calfskin that has been
prepared for calligraphy and
illumination.

Versal
A capital letter from an alphabet of
Romanseque origin, so called because it was used to plot
the opening of a new verse.

USEFUL ADDRESSES

THE HOUSTON CALLIGRAPHY GUILD
C/o The Art League
1953 Montrose Boulevard
TX 77006

CHICAGO CALLIGRAPHY COLLECTIVE
PO Box 11333
Chicago
Illinois 60611

SOCIETY FOR CALLIGRAPHY
PO Box 64174
Los Angeles
CA 90064

THE FRIENDS OF CALLIGRAPHY
334 Pala Avenue
Piedmont
CA 94611

SOCIETY OF SCRIBES LTD
PO Box 933
New York
NY 10150

THE BOOKBINDER'S WAREHOUSE INC
31 Division Street
Keyport NJ

THE CALLIGRAPHY SHOPPE
PO Box 715
Safety Harbor
FL 34093

PAPER & INK BOOKS
13309A Sixes Bridge Road
Emmitsburg
MD 21727

PEN, INK
One East Chase Street
Suite 1127
Baltimore
Maryland 21202

JOHN NEAL, BOOKSELLER
1833 Spring Garden Street
Greensboro
NC 27403

INDEX

ACKNOWLEDGEMENTS

BY PERMISSION OF THE ANCIENT ART AND ARCHITECTURE
COLLECTION
page 52 (*left*); page 52 (*right*); page 53 (*right*); page 81 (*below, right*);
page 130 (*right*)

BY PERMISSION OF THE BAYERISCHE STAATSBIBLIOTHEK
MUNCHEN
page 6 Clm 4452, folio 153r

BY PERMISSION OF THE BIBLIOTECA APOSTOLICA VATICANA
page 14 (*left*) Ms Hunter, 201, p134
page 14 (*right*) Ms Hunter, 201, p269
page 122 Cod, Vat. Gr 16226, folio 2
page 111 (*right*) Ms Hunter 206, folio 33r
page 130 (*left*) Ms Hunter 201, p134

BY PERMISSION OF THE BIBLIOTHEQUE NATIONALE PARIS
page 92 Ms Fr. 13091, folio 19v

BY PERMISSION OF THE BODLEIAN LIBRARY, OXFORD
page 13 Ms. DOUCE, 383, PT. 1

BY PERMISSION OF THE BRIDGEMAN ART LIBRARY
page 11; page 12 (*right*); page 80 (*left*); page 81 (*top, right*)

BY PERMISSION OF THE BRITISH LIBRARY
page 10 Lindisfarne Gospels, folio 91
page 36 Cotton Ms Nero, folio 3v
page 56 Addit Ms 34890, folio 1146-115
page 84 Royal 12 C XIX, folio 6
page 80 (*right*) Harley 2904
page 110 (*left*) Add Ms 24686

BY PERMISSION OF THE DEAN AND CHAPTER OF DURHAM
CATHEDRAL
page 12 (*left*) Ms 174, folio 51
page 72 Ms 174, folio 51
page 81 (*left*) Ms A.I. 10, folio 227

BY COURTESY OF THE UNIVERSITY OF LIVERPOOL
page 102 F 2.8, French Book of Hours, David and Bathsheba,
folio 83r

BY PERMISSION OF THE BOARD OF TRUSTEES OF THE
NATIONAL MUSEUMS AND GALLERIES ON MERSEYSIDE
page 114 M 12068 (Eutropius)

BY COURTESY OF THE BOARD OF TRUSTEES OF THE V & A
MUSEUM
page 131 (*top, left*) AL 1504-1896
page 142

BY PERMISSION OF WALTERS ART GALLERY, BALTIMORE
page 110 (*right*) W 809, folio 70, det. IT 94

BY KIND PERMISSION OF MARIE ANGEL
page 152 (*right*)

BY KIND PERMISSION OF TIMOTHY NOAD
page 111 (*below, left*) Patent granting badges to Lister Howell,
prepared in 1990 under the direction of the Garter King of Arms
page 131 (*below, left*) Detail from Patent granting arms to
P.Litherland, prepared in 1993 under the direction of the late
Arundel Herald
page 153 (*right and below, left*)

BY KIND PERMISSION OF HELEN WHITE
page 52 (*below, right*); page 53 (*left*)

BY KIND PERMISSION OF ANTHONY WOOD
page 131 (*right*)

BY KIND PERMISSION OF MARGARET J. WOOD
page 15 (*right*); page 152 (*left*)